DESIGN RULES FOR
LETTERHEADS

DESIGN RULES FOR LETTERHEADS

over 75 examples from the simple to the spectacular

Roger Walton

HDi

HARPER
DESIGN
international

An Imprint of HarperCollins*Publishers*

Design Rules for Letterheads

This edition first published in 2004 by
Harper Design International,
an imprint of HarperCollins*Publishers*
10 East 53rd Street
New York, NY 10022–5299
United States of America

Distributed throughout the world by:
HarperCollins International
10 East 53rd Street
New York, NY 10022–5299
United States of America
Fax: (212) 207 7654

Library of Congress Control Number: 2004104172

ISBN 0-06-058906-X

Edited and designed by
Duncan Baird Publishers
Sixth Floor
Castle House
75–76 Wells Street
London W1T 3QH

Designer: Rachel Cross
Editor: Simon Ryder

04 05 06 07 / 10 9 8 7 6 5 4 3 2 1

Typeset in Trade Gothic
Color reproduction by Scanhouse, Malaysia
Printed in China by Imago

con

tents*

*Really, all you need to know about letterheads.

FOREWORD

The US Postal Service currently delivers around two billion letters per year, of which only five per cent are personal. This service, along with every other postal service in the world, should, in my opinion, be cherished — for I don't think we'll have a mail system in it's present form for very much longer.

In this age of fax, e-mail, cell phones and text messaging, the letter as a means of everyday communication is becoming rarer and rarer; and as a direct consequence of this, each letter becomes more and more expensive to deliver.

In the UK, in my lifetime, we have come from an inexpensive two-tier system of daily postal deliveries: first class post used to mean guaranteed, next-working-day delivery, with second class post being delivered within two or three working days. There were two deliveries every day where I grew up, which was a relatively rural location. Now, there is one delivery a day, and while first class post will get your letter delivered earlier than second class, for a guaranteed next-day delivery you have to use a special service, and pay pounds not pence. But don't get me wrong. I am not intending criticism of the current postal system, I'm just

pointing out that it is changing, and I think will continue to do so until the post becomes an expensive, special service.

However, having said all that, I still marvel at the postal system we currently enjoy. It is to me amazing to think that I can write a letter, drop it in the postbox near to my home, and that for the cost of a few pence this same little package will be delivered, door to door, in a relatively short time.

I think we take this service for granted at our peril. For once it is gone, which I fear it will be without our support, will we ever get it back? So, take my advice: cherish the mail. And write someone a letter today!

INTRODUCTION

WHY YOU NEED THIS BOOK 1

Q: Surely, can't almost anyone design a letterhead?

A: Yes!

Q: Well then, why do I need a designer?

A: Well...

HDR

Visual Communication

Duncan Baird Publishers
Roger Walton
Castle House
Sith Floor
75-76 Wells Street
London
W1T 3QH

Dear Roger

30 October 2003

Attached are our stationery items for your book. The layout
of this page is 'informal' and incorpor... ...illustrative
use of some personal 'mark making'.
My explanations are attached and I hope they are clear and
not too confusing.

Kind regards

Hans Dieter Reichert, AGI

Bradbourne House
East Malling
Kent ME19 6DZ
United Kingdom

T: +44 (0)1732 875 200
F: +44 (0)1732 875 300
E: mail@hdr-online.com
www.hdr-online.com

VAT Reg No. 626 9552 02

DESIGN COMPANY
HDR Visual Communication

DESIGNER / ART DIRECTOR
Paul Arnot, Paul Spencer,
Peter Black / Hans D. Reichert

COUNTRY OF ORIGIN
UK

DESCRIPTION
From left to right:
Letterhead (white paper)
Envelope (recycled paper)
Letterhead (recycled paper)

SPECIAL FEATURES
In this stationery range
different paper stocks (50
gsm recycled and 110 gsm
white) can be chosen, along
with a variety of images (not
shown here), according to the
impression the letter writer
wishes to give.

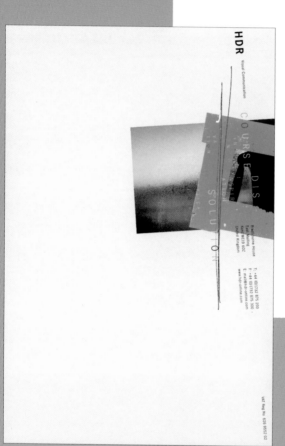

DESIGN COMPANY
HDR Visual Communication

DESIGNER / ART DIRECTOR
Paul Arnot, Paul Spencer,
Peter Black / Hans D. Reichert

COUNTRY OF ORIGIN
UK

DESCRIPTION
From left to right:
Letterhead (recycled paper)
Letterhead (white paper)
Electronic marks (various)

The designers have created a range of electronic marks
(left to right: scribble, scribbled lines, heavy line, and
thick to thin line) which can be placed on the letterhead,
making each one unique, before printing out the letter on
the studio color printer.

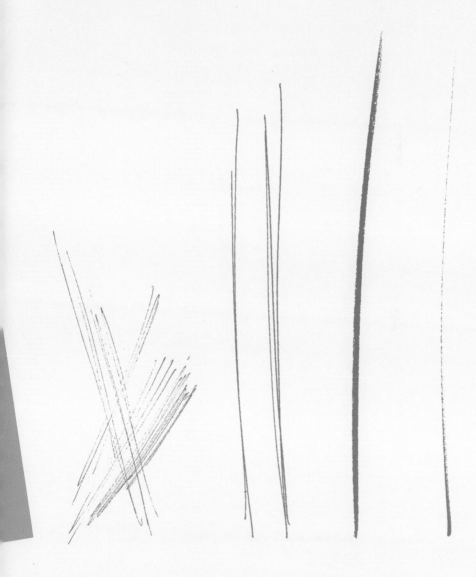

WHY YOU NEED THIS BOOK 2

There are very few situations in life when one has much (some may say any) control, but the design of a letterhead is one where those involved do actually have a great deal of choice and control. The rarity and potential pleasure to be gained from this situation should not be underestimated.

You might think that in this situation the choices are few, and if so just consider this:

The most common American format for a letterhead is a piece of white paper measuring 8 1/2 x 11 inches (216 x 279 mm); in Europe, the standard size, A4, is 210 x 297 mm (8 9/32 x 11 11/16 inches). So, taking the US paper size, let's carve it up into squares measuring 1/16 x 1/16 inches (1.5 x 1.5 mm) to create a grid onto which you can accurately position the information that goes on your letterhead. Well, you now have 23,936 little squares, any one of which could be the starting point of the first line. But which one?

Let's keep this simple. Let's say you want to print your address, and any other information, in one color. The

Pantone® ink-matching system (see pp. 174–75) currently boasts 1,012 colors. So which one would you like? And while we're at it, did you really want white paper? Why not have one of the many hundred colored papers currently provided by American paper mills and recommended for stationery.

So, let's say 1,000 different colored inks and (conservatively) 300 different papers, which gives you a healthy 300,000 potential combinations or, if you prefer, choices to make. This is, of course, before you have even considered where to place the first line of text, not to mention choosing a typeface (or typefaces) or type size (or sizes) yet!

This book is here to help both designers and their clients make informed and creative decisions. The information on these pages is (for the most part) objective, intended to give a basic springboard from which the imagination can take flight (while, hopefully, avoiding printed disasters).

That's it!

OK, THEN...

CHAPTER 1

treatment ™
トリートメント

M + 44 (0)7956 676 451 T + 44 (0)20 7644 6596 F + 44 (0)20 7328 4447 E sam@treatmentuk.com W www.treatmentuk.com
Unit 2A Queens Studios 121 Salusbury Road London NW6 6RG United Kingdom Treatment is a trading name of New State Entertainment Ltd

DESIGN COMPANY
Zip Design Ltd.

DESIGNER / ART DIRECTOR
David Bowden / Peter Chadwick

COUNTRY OF ORIGIN
UK

DESCRIPTION
From left to right:
Letterhead
Compliments slip
Business card (front & reverse)

SPECIAL FEATURE
Note the use of die cutting (see pp. 198–99) to produce rounded corners on the business card.

treatment™
トリートメント

Sam Pattinson サム.パティンソン
Producer プロデューサー

M + 44 (0)7956 676 451 Unit 2A Queens Studios
T + 44 (0)20 7644 6596 121 Salusbury Road
F + 44 (0)20 7328 4447 London NW6 6RG
E sam@treatmentuk.com United Kingdom

www.treatmentuk.com

treatment™
トリートメント

M + 44 (0)7956 676 451 T + 44 (0)20 7644 6596 F + 44 (0)20 7328 4447 E sam@treatmentuk.com W www.treatmentuk.com
Unit 2A Queens Studios 121 Salusbury Road London NW6 6RG United Kingdom

DESIGNERS AND CLIENTS

CLIENT: I would like a letterhead for my company.

DESIGNER: Great!

CLIENT: How long will this take?

DESIGNER: Well, what exactly do you want?

CLIENT: I'm not quite sure. How much will it cost?

DESIGNER: Do you have a budget?

CLIENT: Well, what can I have for a reasonable price?

DESIGNER: That depends on what you have in mind.

CLIENT: I just want a letterhead for my company!

DESIGNER: Let's start again.

A few golden rules:

ASK QUESTIONS

Find out what your client really wants. A client may have many ideas, none of which are based on objective information, or a well researched brief coupled with a clear aesthetic approach, or some combination of the above. Part of the designer's job is to elicit a clear objective brief.

ASK MORE QUESTIONS

Talk to as many of the people who will use the stationery

OK, THEN...

OK, THEN...

every day as possible, because they will know the problems that need addressing by the design, either the new design or a design that is replacing something that has gone before.

SCHEDULE THE WORK

It takes time to do anything well. A letterhead is one of the most sensitive design jobs to be undertaken by any designer, and while the designer may have considerable experience of the process, the client will almost certainly have less. So the process of creating a letterhead and printing it will probably take longer than the client expected (see pp. 28–9).

WRITE THINGS DOWN

Laborious as it sounds, it is always advisable for the designer to take notes at any meeting, and to then briefly confirm in writing to the client all the significant points – particularly regarding schedules and budgets.

CLIENT APPROVALS

A client should always approve and sign off any design before it goes to proof, and any proof of that design before the main print run proceeds.

YOSHO. (Y) 1/// BONEL PLACE # SUITE NUMBER 500 » SAN MATEO, CALIFORNIA 94402 » 650.358.5555 TEL » 650.358.5556 FAX » WWW.YOSHO.COM

yosho

yosho

yosho

DESIGN COMPANY
Segura Inc.

DESIGNER / ART DIRECTOR
Tnop / Carlos Segura, Tnop

COUNTRY OF ORIGIN
USA

DESCRIPTION
From left to right:
Letterhead
Stickers (various)
Continuation page
Letterhead (reverse)

SPECIAL FEATURES
Printing stripes in strong colors on the reverse side of the paper gives a muted pattern through the paper when viewed from the "letter" side. Also, die cut rounded corners have been used throughout this stationery range.

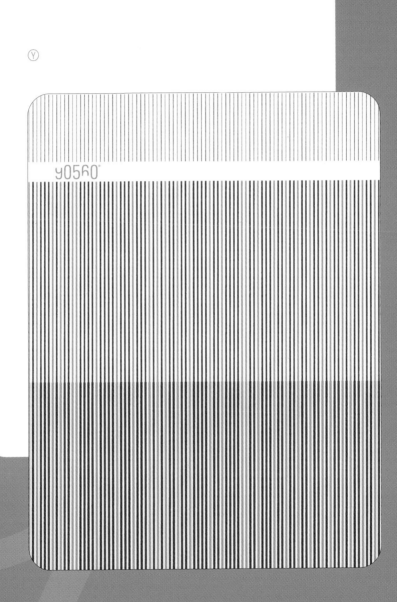

DESIGN COMPANY
Segura Inc.

DESIGNER / ART DIRECTOR
Tnop / Carlos Segura, Tnop

COUNTRY OF ORIGIN
USA

DESCRIPTION
Below:
Business card (front)
Business cards (various, reverse)
Right:
Address labels (two sizes)
Opposite, top to bottom:
Envelopes (various, reverse)
Envelope (front)
Envelope (front and inside)

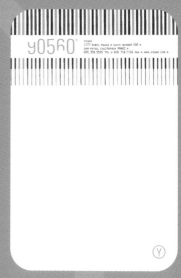

SCHEDULES AND BUDGETS

More than any other aspect of a job, and bizarrely sometimes more than the design itself, tensions can arise over the schedule or budget. So, let's get this straight. The schedule and budget are built around what has to be done, and here's a list:

1. Initial client/designer meeting takes place.
2. Designer responds in writing to client confirming the brief, outlining a rough schedule and budget.
3. Initial design proposals are produced.
4. Second client/designer meeting. Design proposals discussed.
5. Designer responds in writing confirming agreed design direction.
6. Detailed designs are worked up.
7. Third client/designer meeting. Design discussed and approved (or further work agreed).
8. Designer responds in writing confirming any amendments. Designer seeks a number of printer's quotes. Designer discusses quotes with client. Designer appoints printer and discusses schedule. Designer confirms schedule with client.

OK, THEN...

9. Files prepared for printer.
10. Printer provides a proof copy of letterhead.
11. Designer and client approve proof (or not, in which case further work has to be done to generate a second proof).
12. On approval of proof, printer proceeds to print letterhead.
13. Printed letterhead delivered and checked by designer.
14. Letterhead delivered to client.

BUDGETS
The budget will include all of the above, often referred to as the "design budget", plus the printer's charges, which will include materials (paper, film, plates, and ink: see pp. 172–73), the time it takes to make the printing plate or plates, prepare the press ("make ready"), print the letterhead, and "finish" the letterhead (which could mean any trimming, die cutting (see pp. 198–99), or special hand work that needs to be done). There will usually be a delivery charge as well.

CHOOSING YOUR PRIORITIES

In the book 'Everything Reverberates', a collection of design thoughts collated and published by Chronicle Books, Hugh Dubberley offers some of the most illuminating and succinct advice I have come across. He lists three standard requests of many clients when commissioning designers: these are that the design job should be...

1. GOOD
2. FAST
3. CHEAP

...and then he advises the designer to respond by telling the client to...

OK, THEN...

"pick two!"

ImagesofSubstance.com

Lizzy Dann
Duncan Baird Publishers
75–76 Wells Street
London W1T 3QH

Date
October 5, 2003

Re.
Design Submission

Dear Lizzy:
Many thanks for deciding to extend your
deadline to incorporate our submission.
Please find enclosed numerous stationary
sets designed by us over the last few years.
If possible we would prefer you to showcase
the ‚actual' printed matter, rather than

creating facsimiles from our original
FreeHand templates. We see little reason for
wanting to reproduce any work that does
not feature the designers (or clients) final
look of the letterhead, which must include
how the letter is typed—or in some cases

handwritten. Substance has featured in
several of your design anthologies in the
past and we hope you will look favourably
upon our submission. Should you require
further information please do not hesitate to
contact myself.

Sincerely yours,

Neil Fletcher
Arbiter

Substance°

115 Hunter House Road
Sheffield United Kingdom
S11 8TX

E neilfletcher@ImagesofSubstance.com
T +44(0)114 266 2708

Design

Substance®

Partner
Neil Fletcher

Design

T +44(0)114 266 2708 E neilfletcher@ImagesofSubstance.com
115 Hunter House Road Sheffield S11 8TX
United Kingdom

ImagesofSubstance.com

Partner
Neil Fletcher

Image Directory

T +44(0)114 266 2708 E neilfletcher@ImagesofSubstance.com
115 Hunter House Road Sheffield S11 8TX
United Kingdom

DESIGN COMPANY
Substance®

DESIGNER / ART DIRECTOR
Neil Fletcher, Oscar Goldman
(typographer)

COUNTRY OF ORIGIN
UK

DESCRIPTION
From left to right:
Letterhead/résumé
Business cards

SPECIAL FEATURES
This dual-purpose stationery set
acts as the corporate identity for
both Substance® (a graphic
design consultancy) and
ImagesofSubstance.com (an
image directory). Note the
uncommon layout used for the
text of the letter.

formats

FORMATS 1

OK, THEN...

There are good reasons for choosing the most common formats for business stationery (see pp. 36–7), among them being the wide choice of paper types and colors that are available, as well as the equivalent choice for envelopes and other stationery items. There is also the cost to consider: because these formats are so widely used, you will often find that precut paper is very economically priced, and that the printing costs for these formats are keenly priced as well.

You should also consider how the recipient of your letter is going to store it. If they are going to file your letter (see pp. 48–9) you will find that most office storage systems are based around these formats. So, if you choose a different shape or size that format may be more difficult to store, and as such may be less likely to get filed and consequently lost or simply thrown away.

Having pointed this out, there is NO law that says you must choose one of these formats.

FORMATS 2

Here are the two most commonly used formats for letterheads, with their dimensions and internal measurements, which

Width: 8 1/2 inches (216 mm)

Depth: 11 inches (279 mm)

US
IMPERIAL

Folded once in half, depth: 5 1/2 inches (139.5 mm)

Folded twice into thirds, depth: 3 5/8 inches (93 mm)

OK, THEN...

OK, THEN...

depend upon how the sheet of paper is folded (see pp. 42–3) before being placed in an envelope.

Width: 210 mm (8 9/32 inches)

Depth: 297 mm (11 11/16 inches)

EUROPEAN
"A" SIZES (METRIC)

Folded once in half, depth: 148.5 mm (5 11/32 inches)

Folded twice into thirds, depth: 99 mm (3 7/32 inches)

SRD

DIN A 8 (52,5 × 74 mm)

SatzReproDruck

technische Beratung,
Herstellungsbetreuung und
Industrievertretung
für das druckgrafische Gewerbe

BfG Berlin BLZ 100 101 11
Konto 1068 419 100

Telefon 030 704 25 79
Funk 0172 307 72 45
Telefax 030 703 84 69

SRD Wolfgang Glaubitz Catostraße 12 B 12109 Berlin

DIN A 7 (74 × 105 mm)

DIN A 6 (105 × 148,5 mm)

DESIGN COMPANY
atelier: doppelpunkt
kommunikationsdesign gmbh

DESIGNER / ART DIRECTOR
Nauka Kirschner, Petra
Reisdorf, Claudia Trauer,
Birgit Tuemmers

COUNTRY OF ORIGIN
Germany

DESCRIPTION
Letterhead

SPECIAL FEATURES
The design of this stationery
for a producer of "printed
matter" is constructed out of
the "A" size formats (see
p. 37) – the standard German
industrial paper size system.
The letterhead itself is A4.

DIN A 5 (148.5 x 210 mm)

SRD

Telefon 030 704 25 79
Funk 0172 307 72 45
Telefax 030 703 84 69

SRD Wolfgang Glaubitz Catostraße 12 B 12 109 Berlin

Satz ReproDruck

technische Beratung,
Herstellungsbetreuung und
Industrievertretung
für das druckgrafische Gewerbe

Fax-Nachricht

Datum

es folgen Seiten

für

Telefaxnummer

betrifft

mit der Bitte um Nachricht

Angebot

Lieferung

Zusendung

Anruf

Druckfreigabe

Stellungnahme

Erledigung

Kenntnisnahme

Prüfung

Rücksprache

mit freundlichem Gruß

DESIGN COMPANY
atelier: doppelpunkt
kommunikationsdesign gmbh

DESIGNER / ART DIRECTOR
Nauka Kirschner, Petra Reisdorf,
Claudia Trauer, Birgit Tuemmers

COUNTRY OF ORIGIN
Germany

DESCRIPTION
From left to right:
Fax
Business card (front and
reverse)

DIN A 9 (37 x 52.5 mm)

SRD

DIN A 10 (26 x 37 mm)

SatzReproDruck
Wolfgang Glaubitz
Catostraße 12 B
12 109 Berlin

Telefon 030 704 25 79
Funk 0172 307 72 45
Telefax 030 703 84 69

DIN A 9 (37 x 52.5 mm)

SRD

DIN A 10 (26 x 37 mm)

SatzReproDruck
technische Beratung
Herstellungsbetreuung
Industrievertretung

FOLDING

The most common ways of folding a letterhead can be used to the advantage of the design or, if ignored, can detract considerably from its impact. Therefore it is worth thinking about the various options:

FOLDING ONCE, IN HALF

This is usually done in the middle of the long measure, with a crease along the fold, and is easy to do quickly and with accuracy. Normally the letter is folded so that the text, or start of the text, is concealed when the letter is drawn from the envelope. Folding in like this has the advantage of further preserving the privacy of the letter contents (it is sometimes possible to read text through a thin envelope). It also means that there is only one crease through your letter, and if it is to be hole punched and filed this single fold serves as an accurate position guide for the hole puncher (see pp. 136–37). The disadvantage is the cost of envelopes, which tend to be more expensive than the most common variety which accomodates a letterhead folded twice (see below).

FOLDING TWICE, INTO THIRDS — GATEFOLD

This method has to be done accurately, otherwise your letter

OK, THEN...

won't fit in the envelope. So, if you're going for this approach ensure that there is a fold mark — a visual cue to indicate where the first fold needs to be made — printed on your letterhead (see pp. 12–13). The second fold then follows automatically. The advantage of this technique is that if you are using one of the standard sizes of letterhead (see pp. 36–7) you will have the widest possible range of envelopes from which to choose. Like the single-fold system above, the gatefold helps to preserve privacy in a thin envelope.

CONCERTINA FOLD

This system involves making two folds, each one-third the depth of the paper (as with the gatefold above), but you fold the top of the letter back on itself, turn the sheet of paper over so that the "letter" side is facing upwards, and then fold the bottom third up towards the first fold. This creates a "z" or "concertina" fold — so called because it resembles the folds in the air pump of a concertina. This method has one overriding advantage over the first two: the recipient's address can be placed so it appears in the transparent "window" of a window envelope, and you may never have to address an envelope again!

17 JUNE 2003 **Oliver Advertising** \ Gavin Oliver \ 15 Olive Street Parkside SA 5063

Dear Gavin,
Please find enclosed the requested samples of our work and a brief description on who we are.
You can also access further information on VOICE via <www.voicedesign.net>.

I hope the enclosed samples provide a sufficient introduction to VOICE, however, please feel free
to contact me to organise a meeting where we can discuss our services and the agencies requirements
in more detail.

I look forward to speaking with your soon.

Best wishes …

Scott Carslake
[DIRECTOR]

DESIGN COMPANY
Voice Design

DESIGNER / ART DIRECTOR
Scott Carslake

COUNTRY OF ORIGIN
Australia

DESCRIPTION
From left to right:
Letterhead (front and, inset,
when folded)
Letterhead (reverse)

Voice

\ T. 08—8410.8822

F. 08—8410.8933 \ INFO@VOICEDESIGN.NET
VOICEDESIGN.NET

217 GILBERT STREET ADELAIDE SA 5000

SPECIAL FEATURES
This stationery is printed on
both sides, with the name of
the company appearing only
on the reverse side. When the
letterhead is folded,
concertina style (see p. 43),
the company name appears
through the irregular shaped,
die-cut hole in the top left-
hand corner of the
letterhead.

ABN 77 291 602 568

Voice

voice

ANTHONY DE LEO [DIRECTOR]

VOICEDESIGN.NET

217 GILBERT STREET T. 08—8410.8822 ANTHONY@VOICEDESIGN.NET
ADELAIDE SA 5000 F. 08—8410.8933 0411.632.100

voice

VOICEDESIGN.NET

T. 08—8410.8822 \ F. 08—8410.8933
\ INFO@VOICEDESIGN.NET

217 GILBERT STREET ADELAIDE SA 5000

217 GILBERT STREET ADELAIDE SA 5000

voice

F. 08—8410.8933 \ INF

DESIGN COMPANY
Voice Design

DESIGNER / ART DIRECTOR
Scott Carslake

COUNTRY OF ORIGIN
Australia

DESCRIPTION
Left, top to bottom:
Business card
Compliments slip
Above:
Envelope

AI

FILING

Computer technology was supposed to produce the "paperless" office. In fact, since the advent of computers for daily use in offices and at home paper consumption has increased dramatically. It seems we feel the need to keep digital files and hard copies (paper printouts) of everything we consider important. So "filing" in the traditional sense of the word, as well now as in the digital sense, is still with us, and probably will be for years to come.

In designing the various elements of stationery, it is necessary to bare in mind that the item may be filed, and this can have a considerable effect on how the stationery is used. For example, once filed the left-hand edge of the paper, in to about 1 1/2 inches (38 mm), may be obscured by the filing system in which it is held (see pp. 136–37).

OK, THEN...

OK, THEN...

In addition, you need to consider the following:

1. If the letters are going to be kept on file, the filing
 reference system needs to be discussed as part of the
 design brief, so that any reference numbers can be
 accomodated in the letterhead design.

2. If you want recipients to file your letters give them a
 position on the page where their reference can be quoted.

3. Develop a system that works equally well on paper and
 on your computer (see pp. 206–11), ideally with the same
 catalogue codes used for both. You will need both.

COPYING AND FAXING

It is important to check that any preprinted colors used in the letterhead design can be copied by a photocopier and transmitted by a fax machine. A number of paler colors simply do not register when copied, so it is always worth photocopying a printer's proof to check that everything on

COLOR COLOR	COLOR COLOR	COLOR COLOR	COLOR COLOR	COLOR COLOR	COLOR COLOR
COLOR COLOR	COLOR COLOR	COLOR COLOR	COLOR COLOR	COLOR COLOR	COLOR COLOR
COLOR COLOR	COLOR COLOR	COLOR COLOR	COLOR COLOR	COLOR COLOR	COLOR COLOR
COLOR COLOR	COLOR COLOR	COLOR COLOR	COLOR COLOR	COLOR COLOR	COLOR COLOR
COLOR COLOR	COLOR COLOR	COLOR COLOR	COLOR COLOR	COLOR COLOR	COLOR COLOR
COLOR	COLOR	COLOR COLOR	COLOR COLOR	COLOR COLOR	COLOR COLOR

your letterhead that needs to copy does copy. The same is
true with the fax. You have been warned!

Below is a range of colors that either disappear completely
when photocopied, or copy very faintly.

COLOR COLOR	COLOR COLOR	COLOR COLOR	COLOR COLOR	COLOR COLOR	COLOR COLOR
COLOR COLOR	COLOR COLOR	COLOR COLOR	COLOR COLOR	COLOR COLOR	COLOR COLOR
COLOR COLOR	COLOR COLOR	COLOR COLOR	COLOR COLOR	COLOR COLOR	COLOR COLOR
COLOR COLOR	COLOR COLOR	COLOR COLOR	COLOR COLOR	COLOR COLOR	COLOR COLOR
COLOR COLOR	COLOR COLOR	COLOR COLOR	COLOR COLOR	COLOR COLOR	COLOR COLOR
COLOR COLOR	COLOR COLOR	COLOR COLOR	COLOR COLOR	COLOR COLOR	COLOR COLOR

Martijn Oostra, graphic designer

studio, Donker Curtiusstraat 25e, NL-1051 JM Amsterdam

The Netherlands

tel/fax +31 (0)20 / 688 96 46

e-mail studio@oostra.org

Roger Walton

Ducan Baird Publishers

6th, Castle House

75-76 Wells Street

LONDON W1T 3QH

VERENIGD KONINKRIJK

DESIGN RULES

AMSTERDAM / March 1st, 2001

Martijn Oostra, graphic designer

studio, Donker Curtiusstraat 25e, NL-1051 JM Amsterdam

The Netherlands

Roger Walton

Ducan Baird Publishers

6th, Castle House

75-76 Wells Street

LONDON W1T 3QH

VERENIGD KONINKRIJK

Martijn Oostra, graphic designer PAGE 01 / 01

studio, Donker Curtiusstraat 25e, NL-1051 JM Amsterdam

The Netherlands

tel/fax +31 (0)20 / 688 96 46

e-mail studio@oostra.org

Roger Walton
Ducan Baird Publishers
6th, Castle House
75-76 Wells Street
LONDON W1T 3QH
VERENIGD KONINKRIJK

0044 207 580 5692

DESIGN RULES AMSTERDAM / March 1st, 2001

Dear Roger,

A letterhead is often designed very 'posy'. Often it is like parading with one's own logo. I thought that it would be much friendlier when the address of the receiver of the letter gets more attention then one's own address.

That's why I developed a grid where the address of the addressee, put in the KIX code, will determine the form of the letterhead every time. As the KIX barcode looks different for every addressee, it will make every letter unique in design.

With warm regards,

DESIGN COMPANY
Martijn Oostra
Graphic Design

DESIGNER / ART DIRECTOR
Martijn Oostra

COUNTRY OF ORIGIN
The Netherlands

DESCRIPTION
Left, top to bottom:
Letterhead
Envelope
Right:
Fax template

SPECIAL FEATURES
Here, contrary to the norm, the designer has made the recipient's name and address the main element of the design. The bar code is individually generated from the recipient's address.

PAPER

The paper used for stationery is usually quite absorbent. This stems from the notion that paper for letter writing should quickly absorb the wet ink, thus reducing the risk of smudging. Of course, this is a question of degree: too absorbent and the paper acts like blotting paper; too little absorbency and the ink will sit on the surface of the paper and take a long time to dry. This consideration is still relevant today. If the paper is not absorbent enough, the ink from a bubblejet printer will be equally prone to being smudged, sometimes by the printer itself.

So, when it comes to selecting a paper for stationery there are a number of factors that need to be thought about, all of which affect how it will perform.

WEIGHT OF PAPER

In this context, the weight of a sheet of paper refers to the paper's thickness. In the US, this is expressed in pounds (lbs) per ream (500 sheets) of the standard size of sheet in which the paper is manufactured. This is not a finite system, but varies depending upon the grade of paper. A standard weight for a letterhead in the US is around the 80

lbs mark, with 60 lbs being a little on the flimsy side (as well as semi-transparent), and 100 lbs noticeably heavy. Of course, a "flimsy" or "heavy" feel may be the intended effect.

The European metric system for weighing paper (which is also used in the US) works in grams per square meter (gsm). In Europe, the average weight for a printed letterhead is 100 gsm, with 60 gsm on the light side, and a 160 gsm paper* the heaviest that can pass through a bubblejet printer. (It is always worth checking the manufacturer's specifications before putting a paper through a printer.)

WOVE AND LAID PAPERS
These terms refer to the "finish" or surface of the paper: wove paper (as used in this book) has a smooth surface, while the surface texture of a laid paper is made up of fine ridges. The latter is sometimes felt to give a "traditional" feel to a document.

*For reference, this book is printed on 150 gsm paper.

MORE ON PAPER

In addition to weight and finish (see pp. 54–5), there are other paper characteristics that need to be considered.

COATING

To reduce the absorbency of a paper, and to increase the clarity of the ink on the page, some papers are coated with a mix of chalk and gum, which gives the paper a "hard" surface. The ink sinks only as far as the coating, and remains bright and clear in appearance, rather than sinking into the paper fibers. Different types of coating offer different effects, from high gloss through to full matt*.

COLOR

White paper will copy and fax without problems, as will most pale colors. Stronger colors, and patterned papers, can hamper the reading of any text as well as reducing the legibility of copies. Always test these papers before printing.

OPACITY

This term describes how "see through" a paper is: the higher the opacity, the less see through it is. Also, the more opaque the paper the more clearly the ink will stand out.

OK, THEN...

OK, THEN...

WATERMARK

This refers to a word or logo appearing in the texture of the paper itself. It is usually unobtrusive in normal lighting conditions, but can be seen clearly if the paper is held up to the light. It is possible to have your own watermark incorporated into a paper, but this is probably only practical when ordering large quantities of paper.

RECYCLING

The various papers produced through recycling, using environmently-friendly production processes, are becoming more economical and sophisticated, both in terms of the quality of paper produced and the range of paper choice.

SIZE

Many papers can be supplied to a printer already cut to size, and are consequently very economical as they save both on any cut-off wastage and in the process of trimming (see pp. 198–99).

*The pages of this book are made from a "matt art" paper, which has a relatively non-reflective surface.

atomic
PICTURES

1314 COBB LANE, SUITE B I BIRMINGHAM / AL 35205

205.939.1314 *Fax* 205.939.0585 ATOMICPIX.COM

DESIGN COMPANY
iamalwayshungry / d groupe

DESIGNER / ART DIRECTOR
Nessim Higson, Randy Reed

COUNTRY OF ORIGIN
USA

DESCRIPTION
From left to right:
Letterhead (reverse and front)
Envelope (reverse and front)
Business card (front and reverse)

SPECIAL FEATURES
Difficult to see in reproduction,
but this stationery is printed on both
sides of a highly textured paper.

OK, THEN...

STATIONERY RANGES

A letterhead is often the only piece of stationery required. However, beyond this lies a wide range of additional items, the most common of which is a business card. A reasonably full, but still standard stationery range might consist of the following items:

Letterhead
Letterhead continuation sheet
Letter card
Compliments slip
Envelope
Address label
Business card
Invoice
Order form
Fax sheet

Over and above this there are any number of specialist items of stationery that might be required.

OK, THEN...

270 Lafayette Street New York NY 10012 T 212 324 9000 F 212 324 9010

Jennifer Farley
CFO
jen@lunchtv.com

270 Lafayette Street
New York NY 10012
T 212 324 9000
F 212 324 9010

DESIGN COMPANY
Stoltze Design

DESIGNER / ART DIRECTOR
Tammy Dotson / Clifford Stoltze

COUNTRY OF ORIGIN
USA

DESCRIPTION
From left to right:
Letterhead
Business card (front and
reverse)

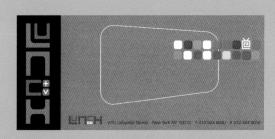

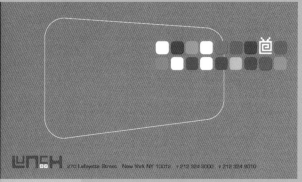

DESIGN COMPANY
Stoltze Design

DESIGNER / ART DIRECTOR
Tammy Dotson / Clifford Stoltze

COUNTRY OF ORIGIN
USA

DESCRIPTION
Clockwise from above:
Compliments slips (two sizes)
Address labels (two sizes)
Envelope (reverse and front)

Jennifer Farley
CFO
jen@lunchtv.com

270 Lafayette Street
New York NY 10012
T 212 324 9000
F 212 324 9010

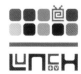

270 Lafayette Street
New York NY 10012

T 212 324 9000
F 212 324 9010

LUNCH 270 Lafayette Street New York NY 10012

OK, THEN...

LETTERHEADS & BUSINESS CARDS

OK, THEN...

The design challenge here is how to visually link a letterhead with a piece of stationery approximately a twelfth of its size, namely a business card. The answer is in the relative relationships between the common typographic elements and any other elements in the design.

So, let's be clear what it is that you're aiming for: a close and memorable visual connection between two pieces of stationery. And why? Well, at an initial business meeting you might hand someone your business card. This card serves two purposes: it gives the recipient your contact details and it reminds them of WHO YOU ARE! When that person subsequently receives a letter from you, the visual appearance of the letter (before they have consciously read a single word) should connect in their minds with your business card, and hence you.

That's the point!

68

nessim**higson**
ViSUaL COMMUNiCaTiON

BALANCING ONE IDEA AFTER ANOTHER

DESIGN COMPANY
iamalwayshungry

DESIGNER / ART DIRECTOR
Nessim Higson

COUNTRY OF ORIGIN
USA

DESCRIPTION
From left to right:
Letterhead (front)
Letterhead (reverse)
Business cards (various,
front and reverse)

SPECIAL FEATURES
This stationery range is
printed on both sides. The
business cards are designed
to accomodate a change of
address, with this information
being individually printed on
to the reverse side using a
rubber stamp.

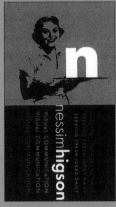
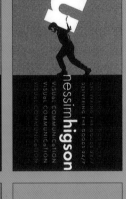
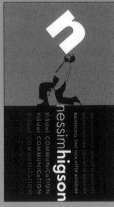

OK, THEN...

COMPLIMENTS SLIPS & ENVELOPES

These two items of stationery are intended to build on the letterhead and business card.

OK, THEN...

COMPLIMENTS SLIPS

The compliments slip (or "comp" slip as it is usually referred to) is an incredibly useful, very economic piece of stationery. Often closely based on the top third of a letterhead design, the comp slip allows the sender great license in the tone of message sent. It can be formal, with no message other than the printed "with compliments"; it can be brief, formal if required, but less so than a full letter; or it can be very informal – handwritten and personal. But in all cases it is still a communication from your company, reminding the recipient of your company's existence.

ENVELOPES

An envelope printed with details of your company is pure advertizing. It simply creates an awareness, beyond the recipient of the letter, of your company. (It also makes it easier for the delivery service to return your mail if they need to.) A printed envelope really says: "Here I am. And look, my business is successful enough to afford this too!"

344

three forty four design

101 n. grand avenue, suite 7
tel/fax: 626.796.5148

pasadena, ca 91103
e-mail: three44@earthlink.net

DESIGN COMPANY
344 Design, LLC

DESIGNER / ART DIRECTOR
Stefan G. Bucher

COUNTRY OF ORIGIN
USA

DESCRIPTION
From left to right:
Letterhead
Business card (front and
reverse)

DESIGN COMPANY
344 Design, LLC

DESIGNER / ART DIRECTOR
Stefan G. Bucher

COUNTRY OF ORIGIN
USA

DESCRIPTION
Clockwise from left:
Compliments slip
Sticker
Mailing label
Stickers
Card

344

three forty four design 101 n. grand avenue, suite 7 pasadena, ca 91103

☑ **contains:**
○ artwork
○ disc
○ information
○ invoice

○ letter (business)
○ letter (personal)
○ mash note
○ threat ○ veiled
○ miscellaneous

☑ **contains:**
● artwork
○ disc
○ information
○ invoice

○ letter (business)
○ letter (personal)
● mash note
○ threat ○ veiled
○ miscellaneous

☑ **contains:**
○ artwork
○ disc
○ information
○ invoice

○ letter (business)
○ letter (personal)
○ mash note
○ threat ○ veiled
○ miscellaneous

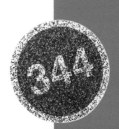

10 easy ways to improve your day

01 put on some good music
02 look at the sky
03 get a chocolaty beverage
04 read the new yorker
05 draw something (even if you can't draw)
06 water your plants
07 pet a fluffy animal (or, if available, a scrumptious human)
08 bounce around the room
09 take a look at www.344design.com
10 smile

OK, THEN...

INVOICES AND ORDER FORMS

OK, THEN...

A quick word about invoices and order forms.

INVOICES

In this digital age there are many good computer programs that will calculate invoices for you, and print them out in a presentable form. There is no denying this innovation is particularly useful to small businesses, who do not have the luxury of a fully fledged accounts department.

So there is a good case that the invoice as a piece of preprinted stationery is becoming irrelevant. However, it seems to me that the invoice still needs to have a strong visual connection with other items of stationery, and this should not be overlooked or dismissed in a stationery range.

ORDER FORMS

There are a number of "off-the-shelf" order forms and order form pads available in stationery stores. There are also computer programs that can generate order forms, in the same way they can generate invoices. But it is the same for order forms as for invoices: for maximum effect they need to have a strong visual link to the rest of your stationery.

78

DESIGN COMPANY
Voice Design

DESIGNER / ART DIRECTOR
Anthony De Leo

COUNTRY OF ORIGIN
Australia

DESCRIPTION
Opposite:
Letterhead (front)
Overleaf, left to right:
Letterhead (reverse)
Business cards (various, front
and reverse)

SPECIAL FEATURES
All the stationery items here
are printed on both sides, with
the reverse sides featuring
different line images, words,
or phrases connected to the
activity of the company.

Tailors of Distinction

Hyde Park
246 Unley Road, Hyde Park
South Australia 5061
Telephone 08 8373 5658
Facsimile 08 8172 2176

David Jones
2nd Floor David Jones
100 Rundle Mall Adelaide 5000
Telephone 08 8305 3481

info@tailorsofdistinction.com
www.tailorsofdistinction.com

DIAGRAM 28.

Tailors of Distinction

Tim Horbury
246 Unley Road, Hyde Park
South Australia 5061
Telephone 08 8373 5658
Facsimile 08 8172 2176
Mobile 0418 836 194

tim@tailorsofdistinction.com
www.tailorsofdistinction.com

82

Dear Valued Customer,

Tailors of Distinction takes pride in its tailoring and alteration workmanship. You may find the off-cuts and any spare buttons from your alteration are pinned to the garment, these may be used for future repairs and adjustments. In the unlikely event the garment altered is not 100% to your satisfaction, please do not hesitate to contact us and we will rectify it immediately.

Other services we offer are Made to Measure Suits, Trousers and Skirts for Ladies and Gentlemen, Ready Made Suits, Dry Cleaning, Invisible Mending and Courier Service to home or work.

"Your personal tailors"
Tailors of Distinction

David Jones Telephone 08 8305 3481 **Hyde Park** Telephone 08 8373 5658

ALTERATIONS

DESIGN COMPANY
Voice Design

DESIGNER / ART DIRECTOR
Anthony De Leo

COUNTRY OF ORIGIN
Australia

DESCRIPTION
Left, top to bottom:
Alterations card (front and reverse)
Swatch card
Opposite:
Satchel (closed and open)

SPECIAL FEATURES

The die cut satchel (which is designed to contain spare garment fabric and washing instructions) continues the iconography of the rest of the stationery range.

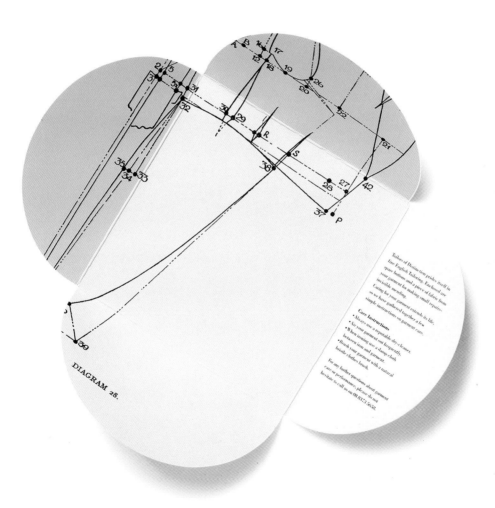

DIAGRAM 28.

Tailors of Distinction prides itself in fine English Tailoring. Enclosed are spare buttons and a piece of fabric from your garment for making small repairs. Caring for your garment extends its life, so we have gathered together a few simple instructions on garment care.

Care Instructions

• Always use a reputable dry-cleaner.
• Air your garment out frequently.
• When ironing use a damp cloth between iron and garment.
• Brush your garment with a natural bristle clothes brush.

For any further questions about garment care or performance, please do not hesitate to call us on 08 8375 3658.

TYPOGRAPHY

CHAPTER 2

DESIGN COMPANY
Yam

DESIGNER / ART DIRECTOR
Craig Yamey

COUNTRY OF ORIGIN
UK

DESCRIPTION
From left to right:
Compliments slip
Business card
Letterhead

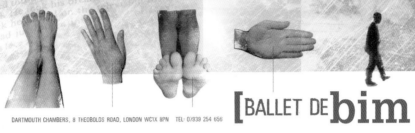

DARTMOUTH CHAMBERS, 8 THEOBOLDS ROAD, LONDON WC1X 8PN TEL: 0/939 254 656

[BALLET DE **bim**

TYPEFACES 1: WEIGHTS

Just so we all know what we're talking about, and can avoid those conversations about "the wiggly bit at the bottom of the g" or "the big letters" etc., this section deals with how typefaces are measured and described.

A this is a capital, or upper-case letter
a this is a lower-case letter
A this is a small capital letter, or small cap, which is equal in height to a lower-case "x" in the same font (see x-height, p. 93)

The terms "upper case" and "lower case" are derived from the time when type was set by hand. The typesetter would take individual metal letters (see p. 91) and place them in a composing stick to make up words and lines. These letters were stored in wooden cases: the capital letters were stored in the upper case; the other letters in the lower case.

Roman, regular, or medium is the term used to describe the standard thickness, or "weight", of the lines that make up a character. The term "roman" refers back to the time of ancient Rome, when messages intended to be widely seen

were chiseled into stone. These inscriptions were beautifully laid out, and executed with great skill. The weight of type used then has lent the term roman to the standard weight of many typefaces. This term is now becoming less common.

In most typefaces there are a number of weights thicker than the roman, and a number thinner. Here is the basic range using the typeface Univers:

Light	thinner or paler than the roman
Roman	the standard weight
Bold	thicker or blacker than the roman
italic or *oblique*	slanting to the right, from bottom to top

Note how different weights affect the look of the face and sometimes the width of the individual characters.

This is Univers light.
This is Univers medium.
This is Univers bold.
This is Univers medium italic.

TYPEFACES 2: SIZES

A "point" (pt) is the unit of measurement used to describe the size of a typeface. It comes, along with "ems" and "ens" (see below), from the days when type was set in metal*.

HOW BIG IS A POINT?

Nowadays, most digital typesetting machines take a point to be exactly 1/72 of an inch (0.035 mm) – in other words there are 72 points to the inch (28.5 to the centimeter). Twelve points make one pica. However, this has not always been so. Traditionally, the American and British point is very slightly smaller than this, while in continental Europe the larger Didot point was used, of which there are 67.5 to the inch (26.5 to the centimeter).

EMS AND ENS

Originally, an "em" was a piece of lead spacing used in metal typesetting which when seen from above was square in shape. The size of an em related directly to the size of type – thus an 8 pt em is eight points in width, whereas a 10 pt em is ten points in width. Today, this name is used to describe a set amount of spacing between two characters in a text. An "en" is half the width of an em.

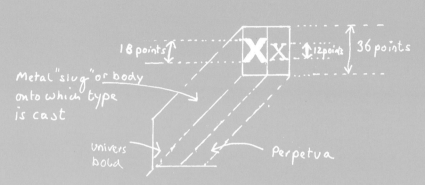

*It is important to understand this connection in order to grasp what a point, as a unit of measurement, actually measures. The point size of a typeface refers to the "body" or "slug" of lead onto which the character was cast in the days of metal setting (see above), not the character itself. For this reason, the point size is only an *indication* of the size of the characters: 8 pt Univers is the size of a Univers character cast onto an 8 pt body of lead; 8 pt Perpetua is much smaller, because the design of Perpetua has a much smaller character height, but it was still cast onto an 8 pt body. These differences are important to bear in mind when considering legibility.

TYPOGRAPHY

aligning 1 2 3 4 5 6 7 8 9 10 baseline

non aligning 1 2 3 4 5 6 7 8 9 10 baseline

cap height

x height

base line

TYPEFACES 3: USEFUL TERMS

BASELINE
The invisible line on which the letters sit. Some elements of the letters, such as descenders (see p. 94–5), lie below this line.

CAP HEIGHT AND X-HEIGHT
The distance between the baseline and the top of the upper-case letters is known as the "cap height", while that between the baseline and the top of the lower-case letters (measured using the lower-case "x") is the "x-height".

LEADING
In the days of metal typesetting, thin strips of lead were inserted between lines of type to increase legibility. This technique has given us the term "leading", which describes the distance (in points) between the baselines of two lines of type that have been set slightly apart in this manner. "Set solid" is the term used when no leading has been employed.

NUMERALS
"Lining" or "aligning" numerals sit on the baseline and align with the cap height. "Non-aligning" numerals vary in size, and can have ascenders and/or descenders (see pp. 94–5).

TYPEFACES 4: MORE USEFUL TERMS

The naming of parts, in this case letterforms:

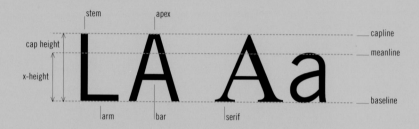

TYPOGRAPHY

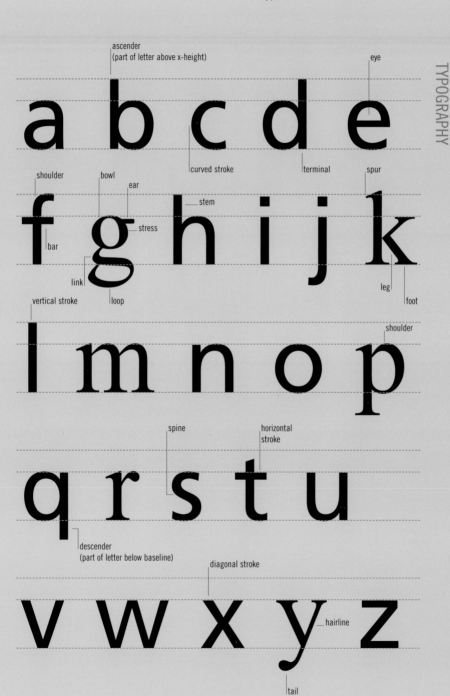

ascender
(part of letter above x-height)

eye

curved stroke

terminal

spur

shoulder

bowl

ear

stem

stress

bar

link

leg

foot

vertical stroke

loop

shoulder

spine

horizontal
stroke

descender
(part of letter below baseline)

diagonal stroke

hairline

tail

CCAC

California College of Arts and Crafts

MICHAEL S. ROTH

San Francisco/Oakland

Art Architecture Design

510.594.3630 FAX 510.594.3797

5212 Broadway

Oakland, CA 94618

www.ccac-art.edu

OFFICE OF THE PRESIDENT

CCAC

California College of Arts and Crafts

MICHAEL S. ROTH

San Francisco/Oakland

Art Architecture Design

510.594.3630 mroth@ccac-art.edu

OFFICE OF THE PRESIDENT

DESIGN COMPANY
Aufuldish & Warinner

DESIGNER / ART DIRECTOR
Bob Aufuldish

COUNTRY OF ORIGIN
USA

DESCRIPTION
From left to right:
Letterheads (two sizes)
Business card (front and reverse)

98

CCAC

1111 **Eighth** STREET
San Francisco, CA 94107
415.703.9500
www.ccac-art.edu

California College of **Arts** and **Crafts**
San Francisco/Oakland
ART **Architecture Design**

DESIGN COMPANY
Aufuldish & Warinner

DESIGNER / ART DIRECTOR
Bob Aufuldish

COUNTRY OF ORIGIN
USA

DESCRIPTION
Letterheads
Business cards (front
and reverse)

SPECIAL FEATURES
This cleverly designed
stationery individualizes
each person's letterhead and
card, while still creating a
coherent corporate identity.

CCAC

1111 **Eighth** STREET
San Francisco, CA 94107

www.ccac-art.edu

California College of **Arts** and **Crafts**

CCAC

Katharine **Chao**
assistant director extended education
510.594.3774
FAX 510.428.1346

kchao@ccac-**art**.edu

CALIFORNIA College of ARTS and Crafts

CCAC

CALIFORNIA College of Arts and Crafts
San Francisco/Oakland
Art ARCHITECTURE DESIGN

5212 Broadway
Oakland, CA 94618
510.594.3600
510.655.3541 FAX
www.ccac-art.edu

CCAC

5212 Broadway
Oakland, CA 94618

www.ccac-art.edu

CALIFORNIA College of Arts and Crafts

CCAC

Erin E. **Lampe**
director *of* publications

415.703.9543
FAX 415.703.9524

elampe@ccac-**art**.edu

California College of **Arts** and Crafts

94615
Oakland, ca.
5212 Broadway ←

Art ARCHITECTURE DESIGN

CCAC

CALIFORNIA College of Arts and Crafts
San Francisco/Oakland

94615
Oakland, ca.
5212 Broadway ←

Art ARCHITECTURE Design

CCAC

CALIFORNIA College of Arts and Crafts
San Francisco/Oakland

OFFICE OF THE PRESIDENT

94107
San Francisco, ca.
1111 Eighth street ←

ART Architecture Design

CCAC

California College of Arts and Crafts
San Francisco/Oakland

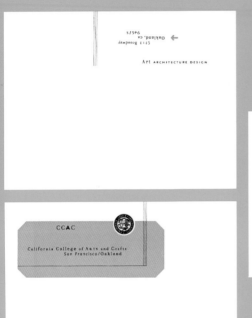

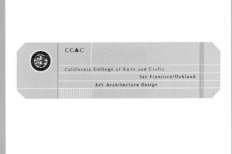

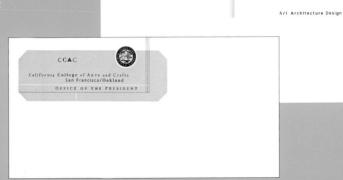

DESIGN COMPANY
Aufuldish & Warinner

DESIGNER / ART DIRECTOR
Bob Aufuldish

COUNTRY OF ORIGIN
USA

DESCRIPTION
Opposite:
Envelopes (various, front
and reverse)
Above and right:
Cards (various)

TYPOGRAPHY

TYPE CLASSIFICATION SYSTEMS

Traditionally, typefaces could be split into two major groups: serif and sans serif, meaning typefaces with serifs (see pp. 94–5) and typefaces without serifs. However, the ever increasing number and variety of typeface designs means that this basic distinction no longer really does the job; but a classification system consisting of scores of different groups seems unnecessarily confusing. So here, I will describe what I consider to be the four main typeface groups: serif, sans serif, block serif, and script.

TYPOGRAPHY

Architectenbureau Marlies Rohmer BV

Architectenbureau Marlies Rohmer BV

DESIGN COMPANY
Lies Ros

DESIGNER / ART DIRECTOR
Lies Ros

COUNTRY OF ORIGIN
The Netherlands

DESCRIPTION
Opposite, top to bottom:
Continuation page
Letterhead
Top to bottom:
Business card (front and
reverse)
Address label
Envelope

SERIF

Serifed faces are all those typefaces that use serifs (see p. 94) as part of their design. Since the 15th century, when the printer Nicolas Jonson (1430–1480) cut type based on roman letter forms (see pp. 88–9), serifed faces have been widely used.

There is an argument which claims that for lengthy amounts of reading a serifed face is more helpful to the eye – the serifs leading the eye from one letter to the next. Against this, some contemporary research suggest that the brain does not "read" the characters in a word sequentially, instead processing words complete, almost like taking a snapshot in order to gain the meaning of the word.

I think it is true to say that the use of serifed faces in stationery give it a more traditional feel. But that is not to say they are all alike: note the range of appearances even in the small sample of tried-and-tested serifed typefaces shown on the opposite page.

TYPOGRAPHY

Here are some classic serifed faces (typeface names are in 12 point, sentences in 10 point):

Baskerville	The quick brown fox jumped over the lazy river.
Bodoni	The quick brown fox jumped over the lazy river.
Ehrhardt	The quick brown fox jumped over the lazy river.
Filosofia	The quick brown fox jumped over the lazy river.
Perpetua	The quick brown fox jumped over the lazy river.
Times	The quick brown fox jumped over the lazy river.

DESIGN COMPANY
Zip Design Ltd.

DESIGNER / ART DIRECTOR
Hannah Woodcock / Peter Chadwick

COUNTRY OF ORIGIN
UK

DESCRIPTION
From left to right:
Address label
Business cards (fronts and reverse)
Letterhead (reverse and fronts)

SPECIAL FEATURES
This stationery range rings the
changes by printing the same
design in a number of different
strong colors. On the business
cards, each person's name is set
in a different typeface.

ZIP DESIGN
UNIT 2A
QUEENS STUDIOS
121 SALUSBURY ROAD
LONDON
NW6 6RG
WWW.ZIPDESIGN.CO.UK
TELEPHONE 020 7372 4474
FACSIMILE 020 7372 4484
ISDN 020 7328 2816
EMAIL INFO@ZIPDESIGN.CO.UK
ESTABLISHED. 1996
ZIP DESIGN LTD
A NEW STATE COMPANY
REGISTERED IN ENGLAND
NO. 3186711 VAT NO. 676 0140 45

ZIP DESIGN
UNIT 2A
QUEENS STUDIOS
121 SALUSBURY ROAD
LONDON
NW6 6RG
WWW.ZIPDESIGN.CO.UK
TELEPHONE 020 7372 4474
FACSIMILE 020 7372 4484
ISDN 020 7328 2816
EMAIL INFO@ZIPDESIGN.CO.UK
ESTABLISHED. 1996
ZIP DESIGN LTD
A NEW STATE COMPANY
REGISTERED IN ENGLAND
NO. 3186711 VAT NO. 676 0140 45

ZIP DESIGN
UNIT 2A
QUEENS STUDIOS
121 SALUSBURY ROAD
LONDON
NW6 6RG
WWW.ZIPDESIGN.CO.UK
TELEPHONE 020 7372 4474
FACSIMILE 020 7372 4484
ISDN 020 7328 2816
EMAIL INFO@ZIPDESIGN.CO.UK
ESTABLISHED. 1996
ZIP DESIGN LTD
A NEW STATE COMPANY
REGISTERED IN ENGLAND
NO. 3186711 VAT NO. 676 0140 45

TYPOGRAPHY

SANS SERIF

"Sans serif" type is quite literally type "without serifs" (see p. 94). The first sans serif typeface was designed by William Caslon IV in 1816. The visual appearance of the sans serif face is simpler than its serifed counterpart, and can be employed to great effect: used large for newspaper headlines and posters, it makes a dramatic impression; used small for running text, many sans serif faces are considered more readable than similar point sized serifed faces, as is shown below.

This typeface is 7 point MetaPlus Normal.

This typeface is 7 point Bauer Bodoni.

Here are some classic sans serif faces. Note how the same amount of text produces different line lengths, depending upon the face used (typeface names are in 12 point, sentences in 10 point):

Frutiger	The quick brown fox jumped over the lazy river.
Gill Sans	The quick brown fox jumped over the lazy river.
Helvetica	The quick brown fox jumped over the lazy river.
Meta	The quick brown fox jumped over the lazy river.
Trade Gothic	The quick brown fox jumped over the lazy river.
Univers	The quick brown fox jumped over the lazy river.

Kto. 029 392 3100

Berliner Bank BLZ 100 200 00

vision photos und **RuF** Havelberger Straße 29 10559 Berlin

Ruf Kurfürstendamm 143 10709 Berlin

RuF
Reportagen und features

Ingomar Schwelz

Telefon 030 892 64 29
030 395 68 15
Telefax 030 396 32 61
Funk 0172 397 67 41

vision photos

Rainer Klostermeier und Axel Kull

Telefon 030 397 313 80
Telefax 030 396 32 61

vision@vision-photos.de
www.vision-photos.de

vision photos Havelberger Straße 29 10 559 Berlin

DESIGN COMPANY
atelier: doppelpunkt
kommunikationsdesign gmbh

DESIGNER / ART DIRECTOR
Nauka Kirschner, Petra
Reisdorf, Claudia Trauer,
Birgit Tuemmers

COUNTRY OF ORIGIN
Germany

DESCRIPTION
From left to right:
Address label
Letterhead (RuF, upside down)
Letterhead (vision photos)

SPECIAL FEATURES
Disciplined typography and
style of imagery create
strongly linked stationery
ranges for two companies
(photographers and
journalists/writers) who work
as potential partners.

Berliner Sparkasse
BLZ 100 500 00 Kto. 730 034 933

BLOCK SERIF

Block serif faces, also known as slab serif, is the term used for those typefaces with serifs (see p. 94) that have little or no curvature or bracketing in their design. The serifs are straight, square-cut additional strokes to the main body of the character, which itself most resembles a sans serif letterface, having virtually no thicks or thins.

Here is a selection of block serif faces (typeface names are in 12 point, sentences in 10 point):

Memphis	The quick brown fox jumped over the lazy river.
Fago	**The quick brown fox jumped over the lazy ri**
Caecilia	The quick brown fox jumped over the lazy ri
Clarendon	**The quick brown fox jumped over the lazy ri**
Candida	The quick brown fox jumped over the lazy river
Officina	**The quick brown fox jumped over the lazy river.**

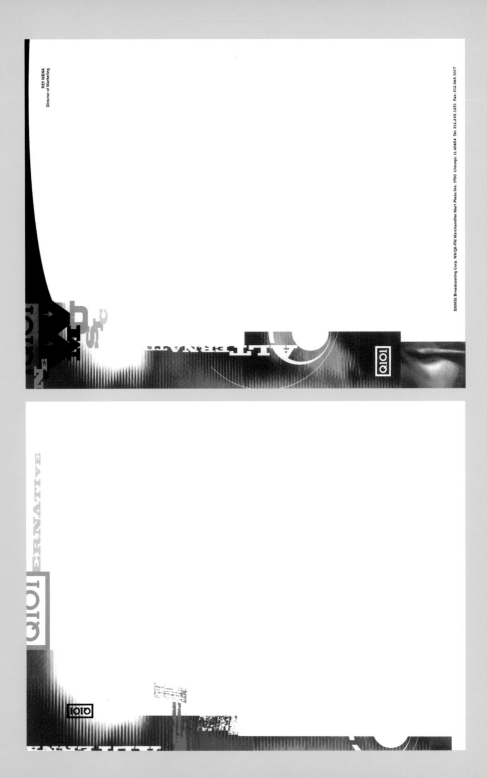

REY MENA
Director of Marketing

EMMIS Broadcasting Corp. WKQX-FM Merchandise Mart Plaza Ste. 1700 Chicago, IL 60654 Tel: 312.245.1251 Fax: 312.464.1017

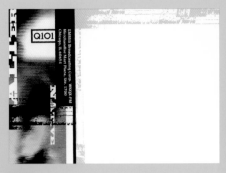

DESIGN COMPANY
Segura Inc.

DESIGNER / ART DIRECTOR
Colin Metcalf, Carlos Segura

COUNTRY OF ORIGIN
USA

DESCRIPTION
Opposite, top to bottom:
Letterhead
Continuation page
Top to bottom:
Address label
Card
Envelope (reverse and front)

SCRIPT

Although there are a number of different script styles, and it is helpful to identify them here, they almost all have two things in common: they are designed to look as though handwritten rather than typeset; and most of the designs are italic. The three main design styles are:

1. Letterforms that look as though created by a brush, where characters do not necessarily connect or join up.

2. Letterforms based on calligraphic writing styles, as if produced by using a flat-tipped pen with its characteristic thick and thin strokes.

3. Letterforms that are based on formal writing styles of the 17th century, and frequently incorporate strokes in the letter design that allow the characters to join up one to the next.

Here is a selection of script faces (typeface names are in 12 point, sentences in 10 point):

Brush Script — *The quick brown fox jumped over the lazy river.*
Zapf Chancery — The quick brown fox jumped over the lazy river.
Du Turner — The quick brown fox jumped over the lazy river.
French Script — The quick brown fox jumped over the lazy river.
Liberty Bell — The quick brown fox jumped over the lazy river.
Shelly Andante — The quick brown fox jumped over the lazy river.

The same typefaces as above (with both names and sentences set in 16 point) to show the type design more clearly:

Brush Script — *The quick brown fox jumped over the la*
Zapf Chancery — The quick brown fox jumped over the laz
Du Turner — The quick brown fox jumped over the lazy river.
French Script — The quick brown fox jumped over the lazy river.
Liberty Bell — The quick brown fox jumped over the lazy river.
Shelly Andante — The quick brown fox jumped over the lazy ri

ROBIN WOOD

F L O W E R S

1902 DANA AVENUE

CINCINNATI, OHIO

4 5 2 0 7

PHONE 513 - 531 - 5590

ROBIN WOOD

F L O W E R S

1902 DANA AVENUE

CINCINNATI, OHIO

4 5 2 0 7

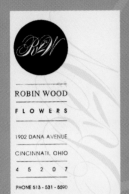

ROBIN WOOD
F L O W E R S

1902 DANA AVENUE

CINCINNATI, OHIO

4 5 2 0 7

PHONE 513 - 531 - 5590

DESIGN COMPANY
Wood / Brod Design

DESIGNER / ART DIRECTOR
Stan Brod

COUNTRY OF ORIGIN
USA

DESCRIPTION
From left to right:
Letterhead
Envelope
Business card

CASE

lower

UPPER AND LOWER CASE

The use of both upper- and lower-case characters is the most common way in which we construct words, sentences, and larger amounts of type. It is a widely recognized method of helping to order and distinguish written information. In a letterhead design, you are often dealing with a relatively small amount of information, but as each part of this has to be clear, easily found, and quickly understood upper- and lower-case characters can have a role to play.

On the other hand, there is no rule that says you cannot use all upper-case characters, or all lower-case characters, or that the exclusive use of either will prevent a good design evolving. But be aware that if you choose to use one or other exclusively you are sacrificing one of the typographic systems of emphasis (see pp. 154–5), that being the change between upper and lower case.

www.doppelpunkt.com atelier@doppelpunkt.com

atelier: doppelpunkt lehrter straße 57 10557 berlin tele +49[0]30 fon 39 06 39-30 fax 39 06 39-40 dfü 39 06 39-50

an duncan baird publishers
roger walton

telefax **0044-20-7580 5692**

umfang 1 page

26th september 2003

design rules for letterheads

dear roger walton,

thank you for asking us to send submissions for »design rules for letterheads«.
we decided to send you a variety of design work (original printed matter). we did so quite
late which means we are going to post this material today. which also means it might be
arriving a bit later than next tuesday, sorry about this!
finally: our english is not perfect, so please excuse our trials on the description of our
work. if you are interested in publishing one (or even more?) of the stationary samples we
will be glad to send you a professional english version.

yours sincerely,

nauka kirschner

DESIGN COMPANY
atelier: doppelpunkt
kommunikationsdesign gmbh

DESIGNER / ART DIRECTOR
doppelpunkt

COUNTRY OF ORIGIN
Germany

DESCRIPTION
From left to right:
Fax page
Letterhead
Business card (front and
reverse)

...kt kommunikationsdesign gmbh
...ottenburg, hrb 61855 **geschäftsführung** nauka kirschner, petra reisdorf, claudia trauer, birgit tümmers

www.doppelpunkt.com atelier@doppelpunkt.com

atelier:doppelpunkt lehrter straße 57 10557 berlin tele +49[0]30 fon 39 06 39-30 fax 39 06 39-40 dfü 39 06 39-50

duncan baird publishers
roger walton
castle house
sixth floor
75–76 wells street

GB-london WIT 3QH

26th september 2003

design rules for letterheads

dear roger walton,

please find the enclosed stationary – according to our today's fax.
if you have any questions please contact me – or my partner claudia trauer.

yours sincerely,

nauka kirschner

atelier:doppelpunkt
lehrter straße 57 10557 berlin

+49[0]30 fon 39 06 39-30 fax -40 dfü -50
www.doppelpunkt.com
atelier@doppelpunkt.com

atelier:doppelpunkt kommunikationsdesign gmbh
amtsgericht charlottenburg, hrb 61855 **geschäftsführung** nauka kirschner, petra reisdorf, claudia trauer, birgit tümmers

DESIGN COMPANY
Goldfinger C.S.

DESIGNER / ART DIRECTOR
D. L. Warfield

COUNTRY OF ORIGIN
USA

DESCRIPTION
From left to right:
Letterhead
Envelope
Business card (front)

SPECIAL FEATURES
The business card is printed
on highly textured card,
reminiscent of the surface
texture of a basketball. This,
along with the particular
orange color, helps to suggest
the activity of the company,
which works with basketball
players.

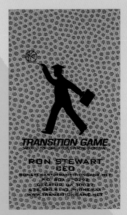

SIZE OF TYPE

The choice of type size is almost infinite. Set against this is the ability of the eye to resolve individual words, which depends not just upon type size but also how your design is going to be seen: whether it will be copied or faxed (see pp. 50–1), or viewed on a computer screen (see pp. 220–25).

Below are a range of type sizes in a serif (Times) and sans serif (Univers) typeface:

12pt: The quick brown fox jumped over the lazy river.
12pt: The quick brown fox jumped over the lazy river.
10pt: The quick brown fox jumped over the lazy river.
10pt: The quick brown fox jumped over the lazy river.
8pt: The quick brown fox jumped over the lazy river.
8pt: The quick brown fox jumped over the lazy river.
6pt: The quick brown fox jumped over the lazy river.
6pt: The quick brown fox jumped over the lazy river.
5pt: The quick brown fox jumped over the lazy river.
5pt: The quick brown fox jumped over the lazy river.
4pt: The quick brown fox jumped over the lazy river.
4pt: The quick brown fox jumped over the lazy river.

TYPOGRAPHY

Below: photocopy of the printout

12pt: The quick brown fox jumped over the lazy river.

12pt: The quick brown fox jumped over the lazy river.

10pt: The quick brown fox jumped over the lazy river.

10pt: The quick brown fox jumped over the lazy river.

8pt: The quick brown fox jumped over the lazy river.

8pt: The quick brown fox jumped over the lazy river.

6pt: The quick brown fox jumped over the lazy river.

6pt: The quick brown fox jumped over the lazy river.

Below: photocopy of the photocopy

5pt: The quick brown fox jumped over the lazy river.

5pt: The quick brown fox jumped over the lazy river.

5pt: The quick brown fox jumped over the lazy river.

5pt: The quick brown fox jumped over the lazy river.

4pt: The quick brown fox jumped over the lazy river.

4pt: The quick brown fox jumped over the lazy river.

4pt: The quick brown fox jumped over the lazy river.

4pt: The quick brown fox jumped over the lazy river.

Below: fax from the printout

12pt: The quick brown fox jumped over the lazy river.

12pt: The quick brown fox jumped over the lazy river.

10pt: The quick brown fox jumped over the lazy river.

10pt: The quick brown fox jumped over the lazy river.

8pt: The quick brown fox jumped over the lazy river.

8pt: The quick brown fox jumped over the lazy river.

6pt: The quick brown fox jumped over the lazy river.

6pt: The quick brown fox jumped over the lazy river.

Below: fax of the fax

5pt: The quick brown fox jumped over the lazy river.

5pt: The quick brown fox jumped over the lazy river.

5pt: The quick brown fox jumped over the lazy river.

5pt: The quick brown fox jumped over the lazy river.

4pt: The quick brown fox jumped over the lazy river.

4pt: The quick brown fox jumped over the lazy river.

4pt: The quick brown fox jumped over the lazy river.

4pt: The quick brown fox jumped over the lazy river.

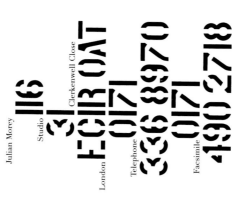

DESIGN COMPANY
Julian Morey Studio

DESIGNER / ART DIRECTOR
Julian Morey

COUNTRY OF ORIGIN
UK

DESCRIPTION
Letterhead

TYPE LAYOUT

There are four standard layouts of type, and by this I mean the relative position of the lines of type to each other, not the position of a block of type within the page.

CENTRED
This means that the lines of type are placed so that the ends of each line are equidistant from an invisible central line (shown below in Times New Roman).

This piece of text is set to show the way lines of type can be positioned relative to each other. There are a number of formal ways, and these have names which come from the metal setting of the past but which are still used today.

JUSTIFIED
In this case, the lines are positioned so that they are all of the same length and aligned vertically with each other.

This piece of text is set to show the way lines of type can be positioned relative to each other. There are a number of formal ways, and these have names which come from the metal setting of the past but which are still used today.

TYPOGRAPHY

RANGE LEFT

This is when there is an invisible straight line down the left-hand side of a block of type, from which all the lines start. The lines make their own length naturally (within a maximum line length), which produces a ragged effect on the right of the block. Usually, the lines are set so that they finish with a complete (rather than hyphenated) word.

This piece of text is set to show the way lines of type can be positioned relative to each other. There are a number of formal ways, and these have names which come from the metal setting of the past but which are still used today.

RANGE RIGHT

The same criteria are used here as in range left, but the straight margin is now on the right-hand side of the block of text and the ragged line ends are on the left.

This piece of text is set to show the way lines of type can be positioned relative to each other. There are a number of formal ways, and these have names which come from the metal setting of the past but which are still used today.

134

DESIGN COMPANY
Aufuldish & Warinner

DESIGNER / ART DIRECTOR
Bob Aufuldish

COUNTRY OF ORIGIN
USA

DESCRIPTION
From left to right:
Envelope
Business card
Letterhead

1303 j street, suite 200
sacramento, ca 95814
916.448.9082x319
916.442.5346 fax

architecture california
the journal of the american institute of architects
california council

arc**CA**

Tim Culvahouse, AIA, editor
tculvahouse@ccac-art.edu

1303 j street, suite 200
sacramento, ca 95814

architecture california
the journal of the american institute of architects
california council

arc**CA**

1303 j street, suite 200
sacramento, ca 95814
916.448.9082x319
916.442.5346 fax

architecture california
the journal of the american institute of architects
california council

arcCA

PAGE LAYOUT

There are many places on a page where the type can be positioned, and you are free to put it anywhere you want. But before doing so consider these few simple points:

1. If you place type within 1/8 inch (3 mm) of the edge of the page you run the risk of that information not showing clearly on either a photocopy or a fax. It is all too easy to accidentally crop off the edges of the page when using these machines, and in any case the copy often fades dramatically towards the edges.

2. If you're in the US and you put information hard on the left- or right-hand side of the letterhead, that information may be lost when it is copied on to the standard European A4 sheet (see pp. 36–7), as this is 5/16 inch (6 mm) narrower than the American equivalent. If, on the other hand, you're in Europe working to the A-size system with the possibility of your letters being copied onto imperial-sized paper, then it is worth noting that the standard A4 page is 18 mm (23/32 inch) longer than its US equivalent, and again information may be lost this time from the top or bottom of the page.

TYPOGRAPHY

3. The standard office hole puncher makes two holes 7/32 inch (5 mm) in diameter, 3 1/8 inches (80 mm) apart center to center, with 7/16 inch (11.5 mm) from the center of the hole to the edge of the paper. If you place information in this area, it's likely to be lost down a hole.

4. When filed, the most readily available section of a letter is its top right-hand corner, extending about halfway across the letter and to just less than halfway down its length. (Just watch someone rifling through a bound file of assorted correspondence if you have any doubts.)

All or none of these points you may consider important – it's your choice!

PAGE LAYOUT

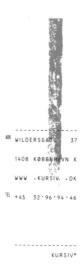

ADR WILDERSGADE 37

1408 KØBENHAVN K

WWW .KURSIV. .DK

TEL +45 32·96·94·46

KURSIV®

DESIGN COMPANY
Kursiv

DESIGNER / ART DIRECTOR
Peter Graabaek

COUNTRY OF ORIGIN
Denmark

DESCRIPTION
From left to right:
Letterhead
Business card
Continuation page

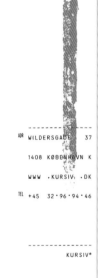

ADR WILDERSGADE 37

1408 KØBENHAVN K

WWW .KURSIV .DK

TEL +45 32·96·94·46

KURSIV®

ORGANIZING THE TEXT

London • Amsterdam

With compliments

William Blake House
8 Marshall Street
London W1F 7BD

Sanredamstraat 19 - I
1072 CB Amsterdam

t +44 (0)20 7734 0282
f +44 (0)20 7439 8884
w www.babycreative.com
e info@babycreative.com

VAT No. 782 3771 04

London • Amsterdam

William Blake House
8 Marshall Street
London W1F 7BD

Sanredamstraat 19 - I
1072 CB Amsterdam

t +44 (0)20 7734 0282
f +44 (0)20 7439 8884
w www.babycreative.com
e info@babycreative.com

VAT No. 782 3771 04

DESIGN COMPANY
Baby Creative

DESIGNER / ART DIRECTOR
Baby Creative

COUNTRY OF ORIGIN
UK

DESCRIPTION
From left to right:
Letterhead
Compliments slip
Business card (front and reverse)

William Blake House
8 Marshall Street
London W1F 7BD

Sanredamstraat 19 - I
1072 CB Amsterdam

t +44 (0)20 7734 0282
f +44 (0)20 7439 8884
w www.babycreative.com
e info@babycreative.com

Baby Creative
London • Amsterdam

SMALL AMOUNTS OF INFORMATION

Dealing with small amounts of information on a letterhead gives, in many ways, the designer and client the most freedom. But beware of the client's information being swamped, or overshadowed by the presence of the letter.

Aside from the text itself, it is important to take into account other essential design elements, such as a fold mark (see pp. 42–3), and how your letter will be used (see pp. 48–9, 136–37), so that vital information isn't obscured or lost.

Even with the minimum of information – a name, postal and e-mail addresses, and telephone details – there is a hierarchy that needs to be carefully considered. The design will evolve out of the relative importance given to each piece of information. However, with the growth of digital communications this basic set of information is now often extended to include a wider range of contact details. Presently, you might well need the following:

Name
Geographical address
 building number / room number
 street name
 town or city
 state / county
 zip / post code
 country
Telephone number
Cell phone / mobile number
Fax number
E-mail address
Website address

Fold mark

The Red Guitar Company Unit 17, Utopia Village, 7 Chalcot Road, London NW1 8LH. Telephone 0171 813 7962. Fax 0171 813 7964. VAT Nº 627 1150 66

DESIGN COMPANY
Julian Morey Studio

DESIGNER / ART DIRECTOR
Julian Morey

COUNTRY OF ORIGIN
UK

DESCRIPTION
From left to right:
Letterhead
Compliments slip
Business card

The Red Guitar Company Unit 17, Utopia Village, 7 Chalcot Road, London NW1 8LH. Telephone 0171 813 7962. Fax 0171 813 7964

Keith Bayley
The Red Guitar Company Unit 12, Utopia Village, 7 Chalcot Road, London NW1 8LH
Telephone 0171 813 7962, Fax 0171 813 7964, Mobile 0860 408350

LARGE AMOUNTS OF INFORMATION

There are often situations when the amount of information required on a letterhead seems formidable: a number of names, possibly more than one logo, company address, subsidiary address or addresses, senior partners' names, company registration number...and so the list can go on.

This can, at first, be quite daunting, but what is needed is a cool head, objectivity, and imagination. As with small amounts of information, a hierarchy of importance needs to be established, and from that will flow infinite possibilities of positioning and emphasis – you can even place information on the reverse side of the paper (see pp. 46–7).

As the needs of a business grow, in addition to the basic set of information (see p. 145) it may be necessary to accomodate some or all of the following:

ORGANIZING THE TEXT

Company logo
Division within company structure
Local office details
> geographical address
> telephone number
> fax number
> e-mail address
> website address
Address where company is registered
Company registration number
Sales tax / VAT number
Senior staff / partners

Fashion Club A division of FIDM®
The Fashion Institute
of Design & Merchandising
919 South Grand Avenue
Los Angeles, California 90015

DESIGN COMPANY
Danielle Foushée Design

DESIGNER / ART DIRECTOR
Danielle Foushée

COUNTRY OF ORIGIN
USA

DESCRIPTION
From left to right:
Envelope (large)
Envelope (small)
Business card (front and reverse)
Overleaf, left to right:
Presentation folder (front)
Letterhead

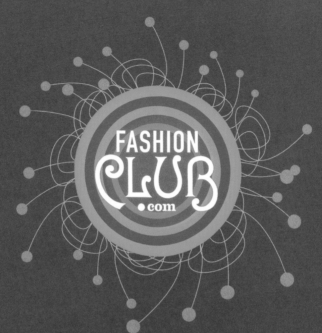

Fashion Club A division of FIDM®

**The Fashion Institute
of Design & Merchandising**

919 South Grand Avenue Los Angeles, California 90015

info@fashionclub.com

SYSTEMS OF EMPHASIS

Once the relative importance of each element of information has been determined, and a hierarchy established, there are four systems of emphasis at the disposal of the designer, which can be used to distinguish and separate those elements:

1. Size of type
2. Weight of type
3. Position of type
4. Color of type

The first three are always available, but the fourth obviously implies the use of more than one tone of a single color, or more than one color.

When using any of these ways to emphasize text, it is the relative contrast between elements that produces the effect. For example, using two sizes of type that are very similar won't help you make much of a dramatic statement – although it may help to imply some needed, but subtle, hierarchy of staff or location, for instance. Where two similar colors are used (say a dark blue and a dark green) to make a distinction,

that distinction will at best be quite fine, and under certain lighting conditions may be lost altogether. Thus, the choice of typeface, and color, is often dictated by the requirements of the information, and it is within the bounds of those objective requirements that the designer's imagination must work.

si*z*e of type

position of type

we*i*ght of type

color of type

156

DOROTHEA VAN CAMP

DOROTHEA VAN CAMP

300 SUMMER STREET
UNIT 35
BOSTON, MA 02210
617.423.6207

www.unit35.com

300 SUMMER STREET | UNIT 35 | BOSTON, MA 02210 | 617.423.6207 | www.unit35.com

DESIGN COMPANY
Stoltze Design

DESIGNER / ART DIRECTOR
Clifford Stoltze

COUNTRY OF ORIGIN
USA

DESCRIPTION
From left to right:
Business card
Letterhead
Portfolio case

FULCRUMCONSULTING

DESIGN COMPANY
R. Walton Studio

DESIGNER / ART DIRECTOR
Roger Walton

COUNTRY OF ORIGIN
UK

DESCRIPTION
From left to right:
Letterheads and business
cards (various)

SPECIAL FEATURES
In this instance, different
colors have been used to
distinguish between the
various departments within
a company.

FULCRUMCONSULTING

7-9 NORTH ST DAVID STREET
EDINBURGH EH2 1AW

TELEPHONE +44 (0)131 524 9510
FACSIMILE +44 (0)131 524 9511
E MAIL mail@fulcrumfirst.com
WEBSITE www.fulcrumfirst.com

Bill Ireland
Eurlng MA CEng MCIBSE MASHRAE

SENIOR ASSOCIATE

FULCRUM CONSULTING
ILLUMINATION

LONDON 62 - 68 ROSEBERY AVENUE, LONDON EC1R 4RR
TELEPHONE +44 (0)20 7520 1300
FACSIMILE +44 (0)20 7520 1355
E MAIL mail@fulcrumfirst.com
WEBSITE www.fulcrumfirst.com

FULCRUM CONSULTING
ACOUSTICS

62 - 68 ROSEBERY AVENUE
LONDON EC1R 4RR

TELEPHONE +44 (0)20 7520 1300
FACSIMILE +44 (0)20 7520 1355
E MAIL mail@fulcrumfirst.com
WEBSITE www.fulcrumfirst.com

Clare Wildfire
MA MIOA

FULCRUM CONSULTING

62 - 68 ROSEBERY AVENUE
LONDON EC1R 4RR

TELEPHONE +44 (0)20 7520 1300
FACSIMILE +44 (0)20 7520 1355
E MAIL mail@fulcrumfirst.com
WEBSITE www.fulcrumfirst.com

Maida Hot
MSc BSc CEng MCIBSE MSLL

HEAD OF ILLUMINATION
DIVISION

FULCRUM CONSULTING
ACOUSTICS

LONDON 62 - 68 ROSEBERY AVENUE, LONDON EC1R 4RR
TELEPHONE +44 (0)20 7520 1300
FACSIMILE +44 (0)20 7520 1355
E MAIL mail@fulcrumfirst.com
WEBSITE www.fulcrumfirst.com

TYPING THE LETTER 1

When preparing a business letter there are a number of points regarding the positioning and formatting of the information to be typed, or input, onto the page which can have a significant affect upon the success of the design.

From the point of view of efficiency, the fewer text "fields" (places where information needs to be input) there are in the letter to move between, the quicker the letter can be generated. Before computers typists would position the paper on the typewriter carriage, roll it up to the correct level, and then set margins and tabs. Obviously the fewer of these mechanical processes that had to take place, the less time was spent on preparation. Thus the most efficient design from the typist's point of view would have been to set one tab only, from which all new lines would range left (see pp. 132–33).

Although this principle of simplicity still holds good, with a computer you can, of course, navigate between different text fields with ease. So, it is necessary not only to design the letterhead but also an easy-to-use computer template to ensure that each letter prints out in the expected

position on the page in relation to the preprinted elements.
There are a number of popular wordprocessing programs
used to generate letters, so the designer must consult
with the client to find out which software they use before
designing a template. This then needs to be tested to make
sure that it is easy to use to a consistently high standard.
Once this is done, the stationery can be printed.

ORGANIZING THE TEXT

E LETTER

TYPING THE LETTER 2

At the beginning of every business letter there is a certain amount of information that is usually present, acting as an introduction to the content of the letter. Assuming that your details are printed on the letterhead, there remain further pieces of information that need to be included:

1. The recipient's details: name, address, etc.
2. The date the letter is written (and sent).
3. The reference number for any reference system you are running.
4. The reference number for any reference system the recipient is running.

All this information needs to be easily identified by the recipient. Not only that, it is important that these "hidden elements" are considered as part of the overall letterhead design, otherwise they can scupper the look of the letterhead when it is actually used. It is therefore essential that they are inserted to a clear and tight specification through the use of a well designed computer template (see pp. 160–61).

Then, of course, there is the letter itself.

HE LETTE

TYPING THE LETTER 3

Before the advent of the now ubiquitous PC, typewriters were all made with one of two sizes of type, and the line spacing was based on a 12-point grid (see pp. 90–1). Nowadays, the choice of type size is bewildering (not to mention the choice of typeface), but it is worth keeping in mind the following points:

1. There is a length of line which is the most comfortable to read, and that is a line that contains between 50 and 60 characters, including the spaces between the words. To gain some idea of what this looks like – most paperback novels have this number of characters per line. A newspaper column, front page news story, is between 30 and 35 characters per line. The human eye and brain are very sensitive to typography: a novel set with 70–75 characters per line will tire most readers before one set with 50–60 characters.

2. If you have long lines to text with little white space, or "leading" (see pp. 92–3), between them the eye finds it hard not to jump about from line to line. This also tires the reader.

3. Be aware that below a certain type size photocopies and fax machines cannot be expected to reliably and accurately copy or transmit type (see pp. 50–1). You may not think that this is important, or that you can gather all the sense you need from the context, BUT in any legal dealing your information needs to be indisputably clear. You do not want that five point "e" to be misinterpreted as an "o", or that "g" as an "8".

with compliments

519 Murray Street
Perth, Western Australia 6000
Tel: (08) 9486 9486
Fax: (08) 9486 9487
E-mail: mikef@stratacom.com.au
Internet: www.stratacom.com.au

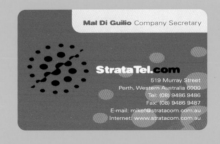

DESIGN COMPANY
Lightship Visual

DESIGNER / ART DIRECTOR
Stuart Medley

COUNTRY OF ORIGIN
Australia

DESCRIPTION
From left to right:
Letterhead
Compliments slip
Business card

PRINTING AND FINISHING

170

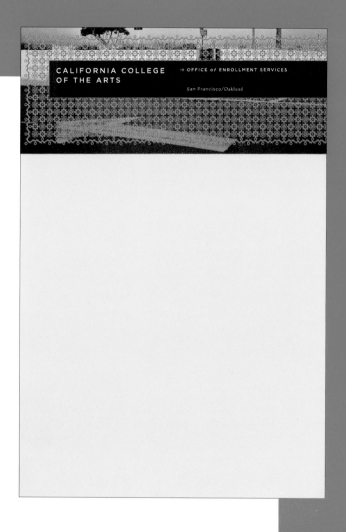

CALIFORNIA COLLEGE
OF THE ARTS

→ OFFICE of ENROLLMENT SERVICES

San Francisco/Oakland

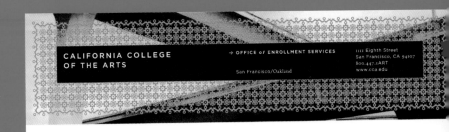

DESIGN COMPANY
Aufuldish & Warinner

DESIGNER / ART DIRECTOR
Bob Aufuldish

COUNTRY OF ORIGIN
USA

DESCRIPTION
From left to right:
Letterhead
Card
Card
Letterhead

SPECIAL FEATURES
Note the way in which differently
colored patterns have been
printed over the consistently
colored elements of this
stationery.

LETTERPRESS AND LITHO

The two main methods of commercial printing are letterpress and litho (or lithographic).

LETTERPRESS

This is now a much less common system than litho printing. It involves ink being rolled onto the raised surface of metal letters, and then paper is pressed onto the inked letters, which transfers the ink to the paper. Letterpress printing has certain characteristics, not least the spacing between each character, which tends to be wider than we are now used to (due to the physical constraints of the process). There is also the "impression" the raised letters leave on the paper, sometimes including a very slight indentation.

LITHO

Lithographic printing is currently the most common commercial printing system. Here, the design is recorded on film. In the past, this film was generated by the type being positioned and printed out as a photographic print. This print was then manually cut and pasted onto a layout grid, along with any images or other design elements, to produce "camera-ready artwork". This was then photographed, and

the photographic negative of each page used to produce the printing plate. Nowadays, CTP (or "computer to plate") technology is cutting out the need for film, instead the digital information is used directly to produce the plate.

The printing plate is coated in a light-sensitive substance that either repels or attracts ink. When this is exposed to light (either through a photographic negative or using CTP technology), where there are letters or other "positive" areas exposure of the plate makes it receptive to ink, while in the "negative" areas the plate becomes ink repelling. Once exposed, the plate is then inked and pressed against the paper, transferring the design to the paper.

ONE-COLOR PRINTING

Whether your design is printed letterpress, litho, or by a printer attached directly to your computer (see pp. 208–11), the simplest and most economical way of printing your letterhead is in one color.

If you are printing letterpress or litho you can select any color from the vast range of printer's inks produced by a number of different companies. You do not have to adhere to the Henry Ford principle of choosing "any color so long as it's black".

There are a number of color-matching systems which are used to specify exactly the characteristics of any color required in a design. The Pantone® and Focoltone® systems are incoporated into the most widely used design software.

Used imaginatively, a single color or tints of that color (see p. 181) can produce just as an effective design as one made with the full range of colors.

DESIGN COMPANY
Deanne Cheuk

DESIGNER / ART DIRECTOR
Deanne Cheuk

COUNTRY OF ORIGIN
USA

DESCRIPTION
Clockwise from below:
Envelope (large)
Letterhead
Business card
Envelope (small)

SPECIAL FEATURES
Note here how the use of
one-color printing does not
necessarily have to mean
the same color for every
item of stationery.

KNEE-HIGH MEDIA
78 Clinton St
1st Floor
New York
NY 10002

Knee High Media US Inc. / 78 Clinton St 1st Floor, New York, NY 10002 / Phone: 212.358.9965 / Fax: 212.358.9962 / letters@kneehigh.com / www.TokionUSA.com

VAT 735 5498 03

192 CLAPHAM HIGH ST T +44 (0)20 7627 0066 F +44 (0)20 7627 0676
LONDON SW4 7UD E mail@mint-design.co.uk W www.mint-design.co.uk

DESIGN COMPANY
Mint

DESIGNER / ART DIRECTOR
Scott Minshall

COUNTRY OF ORIGIN
UK

DESCRIPTION
Clockwise from top:
Promotional rubber mailer
Address label
Compliments slip
Letterhead

SPECIAL FEATURES
This strong design allows the stamping of the logo on the rubber mailer to reinforce the company identity in orange alone, rather than orange and white as elsewhere.

MORE THAN ONE COLOR

It is, of course, theoretically possible to print any number of inks onto one piece of paper, although the practicalities of this may prevent the theory ever being exhaustively tested! However, it is common for stationery to be printed in more than one color, and the relative costs may not be prohibitive. Printing more colors has advantages: information can be emphasized not only by its position in the design, or relative size, but also by color.

Through the use of two colors of ink it is possible to create further colors by overprinting one ink on top of another. Using three colors expands the number of choices yet further, with the results of overprinting becoming numerous. A different effect is achieved when two or more colors are combined through blending.

PRINTING AND FINISHING

EXAMPLE 1: SINGLE COLORS, VARIOUS TINTS

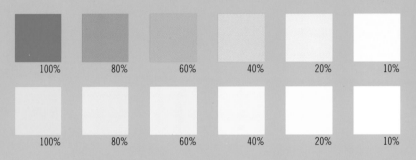

| 100% | 80% | 60% | 40% | 20% | 10% |

| 100% | 80% | 60% | 40% | 20% | 10% |

EXAMPLE 2: TWO COLORS OVERLAPPED, VARIOUS TINTS

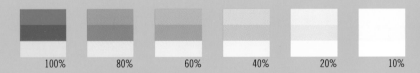

| 100% | 80% | 60% | 40% | 20% | 10% |

EXAMPLE 3: TWO COLORS BLENDED, VARIOUS TINTS

| 100% | 80% | 60% | 40% | 20% | 10% |

DESIGN COMPANY
Segura Inc.

DESIGNER / ART DIRECTOR
Carlos Segura, Tnop (logo) /
Carlos Segura

COUNTRY OF ORIGIN
USA

DESCRIPTION
From left to right:
Letterhead (front)
Letterheads (various, reverse)

SPECIAL FEATURES
This stationery design is
generated from overlaying
design elements produced for
clients, by the studio, in one
year. These are then printed out
on the reverse side of the
studio's stationery to give the
impression of an infinite number
of variations.

www.segura-inc.com
www.segurainteractive.com

segura inc.
info@segura-inc.com

1110 north milwaukee avenue
chicago, illinois 60622.4017 usa
773.862.5667 w 773.862.1214 f

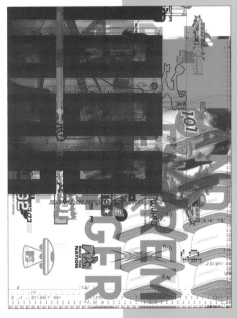

segura inc.
info@segura-inc.com

www.segura-inc.com
www.segurainteractive.com

1110 north milwaukee avenue
chicago, illinois 60622.4017 usa

DESIGN COMPANY
Segura Inc.

DESIGNER / ART DIRECTOR
Carlos Segura, Tnop (logo) /
Carlos Segura

COUNTRY OF ORIGIN
USA

DESCRIPTION
Opposite, top to bottom:
Envelopes (various, inside)
Envelope (front)
Top to bottom:
Address labels (large)
Address labels (small)

SPECIAL FEATURES
The overlaying process
described on the previous
page has been carried
through onto the address
labels, compliments slips,
and even to the extent of
making the envelopes out of
printed paper, the printed
surface of which appears on
the inside!

carlos segura
carlos@segura-inc.com

www.segura-inc.com

1110 north milwaukee avenue
chicago, illinois 60622.4017 usa
773.862.5667 w 773.862.1214 f
773.960.9673 c

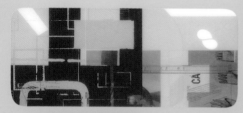
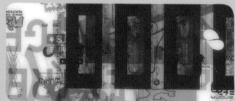

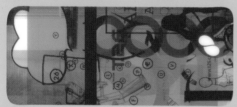
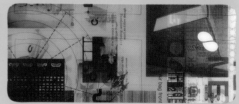

187

DESIGN COMPANY
Segura Inc.

DESIGNER / ART DIRECTOR
Carlos Segura, Tnop (logo) /
Carlos Segura

COUNTRY OF ORIGIN
USA

DESCRIPTION
Business cards (front and
reverse)

SPECIAL FEATURES
These business cards are
printed on thin card, which
is then sandwiched
between two sheets of self-
adhesive plastic, giving
them an unfamiliar tactile
presence.

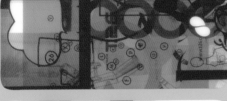

FOUR-COLOR PRINTING

The four-color printing process creates the illusion that the full range of colors the eye can perceive is being used. In fact, the printed four-color image is made up of a number of dots, of varying sizes, printed in one of four colors: cyan, magenta, yellow or black (abbreviated to CMYK*). The size of the dot, and it's proximity to other dots, or whether the dots overlap each other or not, all affect the illusion of seemless full color.

The CMYK system is less commonly used in the printing of stationery because at small sizes printed type made up of dots can become indistinct, or "soft around the edges". At larger type sizes this effect is minimal.

*The letter "K", which stands for "key", is used as the abbreviation for the black color, instead of "B". This stems from the fact that the black is used as the "key" against which the other three color plates are positioned – hence CMYK rather than CMYB.

COMPUTERCAFE
ANIMATION AND VISUAL EFFECTS

DESIGN COMPANY
Segura Inc.

DESIGNER / ART DIRECTOR
Tnop, Ryan Holverson /
Carlos Segura, Tnop

COUNTRY OF ORIGIN
USA

DESCRIPTION
Letterhead (front
and reverse)

3130 SKYWAY DRIVE, SUITE 603,
SANTA MARIA, CA 93455
T. 805.922.9479 F. 805.922.3225

715 BROADWAY, SUITE 310,
SANTA MONICA, CA 90401
T. 310.395.9013 F. 310.395.9814

INFO@COMPUTERCAFE.COM
WWW.COMPUTERCAFE.COM

COMPUTERCAFE
ANIMATION AND VISUAL EFFECTS

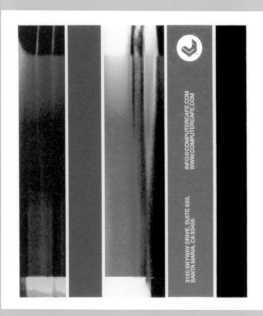

3130 SKYWAY DRIVE, SUITE 603,
SANTA MARIA, CA 93455

INFO@COMPUTERCAFE.COM
WWW.COMPUTERCAFE.COM

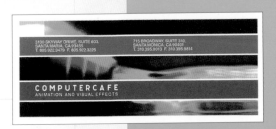

3130 SKYWAY DRIVE, SUITE 603.
SANTA MARIA, CA 93455
T. 805.922.9479 F. 805.922.3225

715 BROADWAY, SUITE 310,
SANTA MONICA, CA 90401
T. 310.395.9013 F. 310.395.9814

COMPUTERCAFE
ANIMATION AND VISUAL EFFECTS

BRUCE BROWN
BRUCE@COMPUTERCAFE.COM

INFO@COMPUTERCAFE.COM
WWW.COMPUTERCAFE.COM

DESIGN COMPANY
Segura Inc.

DESIGNER / ART DIRECTOR
Tnop, Ryan Holverson / Carlos
Segura, Tnop

COUNTRY OF ORIGIN
USA

DESCRIPTION
Clockwise from left:
Business card (front and
reverse)
Business card (circular, front
and reverse)
Envelope (front)
Envelope (reverse)

RHONDA THOMPSON

CAFEFX
A DIVISION OF
THE COMPUTERCAFE GROUP

3130 SKYWAY DRIVE, SUITE 603
SANTA MARIA, CA 93455
T 805.922.9479 F 805.922.3225

RHONDA@CAFEFX.COM
WWW.CAFEFX.COM

SPECIAL INKS

There are a variety of special inks now commercially available, but they all have one factor in common: the smoother the surface of the paper (see pp. 56–7) the more effective these inks will be. The more the paper absorbs the ink the duller the effect will be, and on some papers used for letterheads the results can be quite disappointing.

METALLICS

Metallic inks are made by mixing ground metal into a base color, thus reflecting light and giving the color its sheen. The most common colors are golds, silvers, coppers, bronzes, and a number of "shades" of these exist in most ranges. The variety of metallics is becoming increasingly sophisticated, and it is now possible to find metallic blues, greens, reds, oranges, and purples.

FLUORESCENTS

These inks have been developed relatively recently and can now be found in a number of colors. The molecular structure of a fluorescent ink means that it reflects a higher than average amount of light, thus making the ink appear significantly brighter than non-fluorescent inks.

PRINTING AND FINISHING

THERMOGRAPHY

This is a process which produces a raised effect, similar in appearance to embossing (see pp. 198–99), but without the use of expensive embossing moulds. Special non-drying inks are used in the printing, and when still wet the inks are dusted with a powdered compound. The excess, on the non-printed areas, is removed by suction, and then the sheet is passed under a heated element. The heat fuses the ink and powder together, and this expands and causes the surface of the ink to rise, producing the raised effect.

BLOCKING

This is a heat treatment that allows areas of thin metal foil (most commonly gold leaf) to be stuck to the surface of the paper. It is only rarely used in stationery.

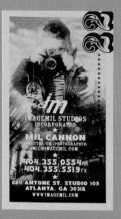

DESIGN COMPANY
Goldfinger C.S

DESIGNER / ART DIRECTOR
D. L. Warfield

COUNTRY OF ORIGIN
USA

DESCRIPTION
From left to right:
Business card
Envelope
Letterhead

SPECIAL FEATURES
Of special note here is the expensive, but effective use of metal foil blocking in the design.

IMAGEMIL STUDIOS, INCORPORATED
684 ANTONE ST. STUDIO 109 ATLANTA, GA 30318
★★★★★★★★★★★

197

★ QUALITY GUARANTEED

IMAGEMIL STUDIOS, INCORPORATED
684 ANTONE ST. STUDIO 109 ATLANTA, GA 30318
404.355.0554 PHONE
404.355.5519 FAX

WWW.IMAGEMIL.COM

FINISHING

TRIMMING

The trimming process always results in a square or rectangular sheet of paper because of the technology used. Often, standard letterhead sizes can be supplied pre-trimmed to the printer, but also a printer will trim a larger sheet down to the size required.

DIE CUTTING

This is a process whereby shapes can be cut out of a sheet of paper, or the whole sheet can be cut into an irregular shape. First, a metal "die" of the exact shape required is created. Each sheet is then stamped with the die, which cuts the paper into the required shape.

EMBOSSING (AND DEBOSSING)

In this process a mould is used to indent the paper: embossing is when the stamped area rises above the surface; debossing when the stamp pushes the area below the surface. Both of these can be done with remarkable precision and crispness.

r+d

ryan-deslauriers
290 Place d'Youville
Montréal · Québec · Canada · H2Y 2B6
T 514.287.1866 · F 514.287.1916
www.ryanonline.com

MONT-TREMBLANT · MONTRÉAL · ATLANTA

DESIGN COMPANY
Ryan & Deslauriers

DESIGNER / ART DIRECTOR
Bob Beck, Tom Pedriks,
Francis Hogan / Bob Beck,
Tom Pedriks

COUNTRY OF ORIGIN
Canada

DESCRIPTION
From left to right:
Continuation page
Letterhead
Envelope (inside)
Envelope (front)
Business card (front and
reverse

Bob Beck
Brand Innovator

ryan+deslauriers
290 Place d'Youville
Montréal · Québec · Canada · H2Y 2B6
T 514.287.1555 x 231 · F 514.287.1918 · C 514.347.5828
bob@ryanonline.com · www.ryanonline.com

r+d

MONT-TREMBLANT · MONTRÉAL · ORLANDO

do great work · have fun · make a difference

ryan+deslauriers
290 Place d'Youville
Montréal · Québec · Canada · H2Y 2B6
T 514.287.1555 · F 514.287.1918
www.ryanonline.com

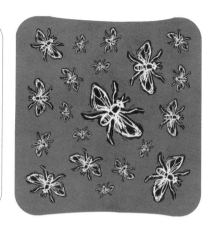

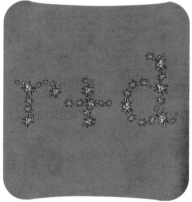

DESIGN COMPANY
Ryan & Deslauriers

DESIGNER / ART DIRECTOR
Bob Beck, Tom Pedriks, Francis Hogan /
Bob Beck, Tom Pedriks

COUNTRY OF ORIGIN
Canada

DESCRIPTION
From top to bottom:
Glass mats (various, reverse and front)
Opposite, top to bottom:
Compliments slip (front and reverse)
CD case (front and inside)

ON SCREEN

CHAPTER 5

FROM MAILBOX TO INBOX

FROM MAILBOX TO INBOX

At the beginning of this book I remarked upon what I consider to be the wonder of the postal system. Despite the fact that almost all the mail we receive today is business or financially related, there is no doubt in my mind that receiving a personal letter is still one of the great simple pleasures of life – the anticipation of opening the letter now heightened due to the rarity of the experience.

Do we honestly get the same *frisson* of expectation from an e-mail? There is no questioning the amazing speed and accuracy of the e-mail system and, like the post before it, it is a great invention. But we have yet to really explore how we might genuinely personalize our electronic mail.

The focus of this book is letterhead design, for the most part for business use, but the implications of the question are still relevant. How do we make our electronic mail particular, eye catching, and memorable? How are we going to apply the rigors and imagination of stationery design to screen-based correspondence?

Indeed, presently, can we?

1

SCREEN TO PRINTER

ON SCREEN

SCREEN TO PRINTER 1

Somewhere between the traditional preprinted letterhead and the paperless e-mail, lies the letterhead printed on a bubblejet or inkjet printer connected directly to the computer. This form of letterhead offers flexibility – even as far as creating an individual letterhead for each letter (see pp. 52–3) – but it can be limited by the quality of the printer.

It may be that the amount of stationery needed does not warrant it being pre-printed. If this is the case, it is perfectly possible to design stationery to be printed direct from the computer. This is often the most appropriate and economical solution to a particular stationery need. However, if this is the path chosen the quality of the printer should be assessed to prevent an unsatisfactory result. Ideally, the printer should be tested printing the letterhead design on the precise paper that will be used for the stationery. The quality of paper can drastically change the appearance of a letterhead printed in this way, so it is worth experimenting.

Both systems have advantages and disadvantages (see pp. 210–11), and these need to be clearly understood by both designer and client before proceeding.

SCREEN TO PRINTER 2

Business letters are now almost always generated on a
 computer, and it is helpful to see all the elements of your
printed letterhead on screen before sending it. It is essential
that the template used to generate the letter is designed for
ease of use, with the text fields set up to be as efficient for
the letter writer as possible.

To do this, the designer and client need to discuss the
computer hardware and software to be used when producing
letters in this way: particularly the computer platform, PC or
Mac, as it cannot be automatically assumed that a design
created on one system will translate accurately onto the
other. However, having said that, once aware that there may
be a problem, a solution can usually be found.

When deciding whether to go the preprinted letterhead or
screen-to-printer route, there are a number of points that
may be helpful to consider:

PREPRINTED LETTERHEADS
1. The print quality is higher. Fine imagery will be sharper.
 The letterforms will be crisper, and you are able to print

smaller type more clearly.

2. Any areas of solid color will be just that, solid color, rather than broken into fine dots, and you can accurately print percentage tints of that color.

3. You have a greater choice of more economically priced papers on which to print.

4. The printed elements of your letterhead will precisely match the other printed stationery items.

5. It is a more economical system over longer print runs (involving larger amounts of stationery).

COMPUTER-GENERATED LETTERHEADS

1. The sharpness of very small type and fine imagery is reduced.

2. The subtlety of any full-color elements is reduced. The color may vary a little from letter to letter.

3. You can change paper stock letter to letter. You can accomodate design changes without wastage.

4. You can adapt design elements on an almost page-by-page basis (see pp. 14–15).

5. It is more economical over short print runs. There are no up-front printer's costs.

D-Fuse

[T] +44 [0]20 7253 3462 [T] +44 [0]20 7566 0181
13-14 GREAT SUTTON ST. LONDON. EC1V 0BX. UK.
[W] WWW.DFUSE.COM [E] INFO@DFUSE.COM

VAT NUMBER **744 3796 04**
RAW-PAW GRAPHICS LIMITED
REGISTERED IN ENGLAND + WALES NUMBER **3085375**

BANK DETAILS · **HSBC. 153 NORTH ST. BRIGHTON. EAST SUSSEX. BN1 1SW. UK.**
ACCOUNT NAME · **RAW PAW GRAPHICS LIMITED**
ACCOUNT NUMBER · **51748815** BANK SORT CODE · **40-14-03**

[T] +44 [0]20 7253 3462 [T] +44 [0]20 7566 0181
13-14 GREAT SUTTON ST. LONDON. EC1V 0BX. UK.
[W] WWW.DFUSE.COM [E] INFO@DFUSE.COM

DESIGN COMPANY
D-Fuse

DESIGNER / ART DIRECTOR
Mike Faulkner

COUNTRY OF ORIGIN
UK

DESCRIPTION
From left to right:
Letterheads (various papers)

SPECIAL FEATURES
The letterhead and delivery
note (shown over the page) are
printed in black only, on the
printer connected to the studio
computer system – about the
simplest system you can have!
Despite this, the stationery is
given variety by printing on a
number of strongly colored
paper stocks.

VAT NUMBER 744 3796 04
RAW-PAW GRAPHICS LIMITED
REGISTERED IN ENGLAND & WALES NUMBER 3085375

BANK DETAILS HSBC. 153 NORTH ST. BRIGHTON. EAST SUSSEX. BN1 1SW. UK.
ACCOUNT NAME RAW PAW GRAPHICS LIMITED
ACCOUNT NUMBER - 51748815 BANK SORT CODE 40-14-03

D-Fuse

3rd FLOOR, 36 GREVILLE ST. LONDON EC1N 8TB. UK. T +44 (0)20 7419 9445
F +44 (0)20 7419 4900 WEB www.dfuse.com E-MAIL clare@dfuse.com

DELIVERY NOTE

DATE **03.11.03**
TO **NO IMMORTAL RECORDS**
WHAT **7 X D-TONATE DVDS**

D-Fuse

[T]+44 [0]20 7253 3462 [T]+44 [0]20 7566 0181
13-14 GREAT SUTTON ST. LONDON. EC1V 0BX. UK.
[W] WWW.DFUSE.COM [E] INFO@DFUSE.COM

D-Fuse

[T]+44 [0]20 7253 3462 [T]+44 [0]20 7566 0181
13-14 GREAT SUTTON ST. LONDON. EC1V 0BX. UK.
[W] WWW.DFUSE.COM [E] INFO@DFUSE.COM

DESIGN COMPANY
D-Fuse

DESIGNER / ART DIRECTOR
Mike Faulkner

COUNTRY OF ORIGIN
UK

DESCRIPTION
From left to right:
Delivery note
Letterhead
Continuation sheet
Overleaf:
Business cards
(various, front and reverse)

SPECIAL FEATURES
The business cards (shown
overleaf) make use of glowing
colors and metal to enhance
their readability in low-light
and UV environments, such as
clubs and new media events.

D-Fuse
UK¬ 13-14 GT. SUTTON ST. LONDON. EC1V 0BX. UK.
T +44 [0]20 7253 3462 E info@dfuse.com
JAPAN¬ AGOSTO, INC.
株式会社アゴスト 〒112 0005東京都文京区水道1-4-6浅野屋ビル3階
3F ASANOYA BLDG. 1-4-6 SUIDOU. BUNKYO-KU. TOKYO. 112-0005.
T +81 [0]3-5684-4751 F +81 [0]3-5684-2977 E judy@agosto.com

■ 04

MIKE FAULKNER ¬DIRECTOR

D-Fuse
PO BOX 39943. LONDON. EC1V 0YZ. UK.
T +44 [0] 20 7253 3462 M +44 [0]7973 655 231
W www.dfuse.com E mike@dfuse.com

■ 01

ANDY STIFF →WEB

D-Fuse
PO BOX 39943. LONDON. EC1V 0YZ. UK.
T +44 [0]20 7266 2108 M +44 [0]7977 194 580
W www.dfuse.com E andy@dfuse.com

■ 03

MIKE FAULKNER →DIRECTOR

D-Fuse
2nd FLR. 13-14 GT. SUTTON ST. LONDON EC1V 0BX. UK.
T +44 [0]20 7253 3462 M +44 [0]7973 655 231
W www.dfuse.com E mike@dfuse.com

■ 02

SCREEN TO SCREEN

E-mail must be one of the most significant advances in communications since the advent of the printing press. We can now almost instantly send a letter from one computer to one (or more) recipients anywhere in the world. As if that in itself isn't enough, it is possible to personalize our messages in completely new ways, with the inclusion of not only images and graphics, but now also sounds, animation, and video — providing, of course, the recipient's computer has all the relevant software to cope with the files.

This is the problem currently: you cannot guarantee that anything but the most simple e-mail message will be displayed by the receiving computer exactly as you intended — or, in some cases, at all! This becomes particularly evident when e-mailing across platforms, from PC to Mac, or vice versa. There is bound to come a time (soon, hopefully) when this is a thing of the past. But that time is NOT now.

ELECTRONIC LETTERHEADS
Of all the different file types used as attachments for e-mails, the PDF* (Portable Document Format) is the one that comes closest to ensuring that what you send is

received unaltered. This format enables you to take a document on your screen, say a letterhead file with a letter typed into it, and convert it into a file which can be read by almost any computer, whether PC or Mac. The beauty of the PDF is that the document is self-contained, possessing all the typefaces, colors, and images specified by the sender. Although pretty reliable, as is demonstrated on the following pages, at the time of going to press the PDF is not 100 per cent foolpoof.

In conclusion, there is no doubt that a more reliable, easy to use, and controllable system of e-mail will evolve, and we'll all be saying: "How can we have lived without...." But, today, in my opinion, if you want to express something particular about your business with a letter, the best way to do this, with all the skill, taste, and care that the document implies, is to print it out and mail it.

*To read a PDF requires a piece of software called Acrobat Reader®. This is sometimes supplied with new computers, or can be downloaded from the Adobe® website (www.adobe.com).

DUNCAN BAIRD PUBLISHERS

Castle House Sixth Floor 75–76 Wells Street London W1P 3RE

Tel 0171 323 2229 Fax 0171 580 5692

Roger Walton

Duncan Baird Publishers

Castle House

75 - 76 Wells Street

London W1T 3QH

22nd January 2004

Dear Roger,

Here is the letter to be used for the example of screen viewed stationery in 'Designer's Rules for Letterheads'. Following our conversation this morning we will reproduce this letter as it appears when printed out on the actual letterhead, and how it appears on screen as a pdf file on my AppleMac. I will then e-mail the pdf to a PC and we will reproduce how the pdf file looks on that screen.

This page:
Preprinted letterhead with computer-generated letter printed onto it, in position, using a bubblejet printer connected directly to the computer. (For the purposes of this book, the Pantone® color gray (number 5565) has been matched to the printed letterhead and reproduced here using the CMYK process (see pp. 188–89).

Overleaf, left:
The original letter file made into a PDF, and viewed on screen using Acrobat Reader® on an Apple Mac computer. The view is set to "fit in window", which displays the entire document on the monitor.

Overleaf, top right:
As above, but with the view set to "actual size", which displays the document at its real physical proportions.

Overleaf, bottom right:
As above, but with the view set to "fit to width", which displays the document so that it fills the width of the monitor, regardless of the size of the monitor.

Duncan Baird Publishers Ltd

Registered office: Craven House 16 Northumberland Avenue London WC2N 5AP

Registered in England: 2650152 VAT number 564 5717 18

DUNCAN BAIRD PUBLISHERS

Castle House Sixth Floor 75-76 Wells Street London W1P 3RE

Tel 0171 323 2229 Fax 0171 580 5692

Roger Walton

Duncan Baird Publishers

Castle House

75 - 76 Wells Street

London W1T 3QH

22nd January 2004

Dear Roger,

Here is the letter to be used for the example of screen viewed stationery in 'Designer's Rules for Letterheads'.
Following our conversation this morning we will reproduce this letter as it appears when printed out on the
actual letterhead, and how it appears on screen as a pdf file on my AppleMac. I will then e-mail the pdf to a PC
and we will reproduce how the pdf file looks on that screen.

Yours sincerely,

Rachel

DBP LETTER.pdf

DUNCAN BAIRD PUBLISHERS

Castle House Sixth Floor 75-76 Wells Street London W1P 3RE

Tel 0171 323 2229 Fax 0171 580 5692

Roger Walton

Duncan Baird Publishers

Castle House

75 - 76 Wells Street

London W1T 3QH

22nd January 2004

Dear Roger,

Here is the letter to be used for the example of screen viewed stationery in 'Designer's Rules for Letterheads'.
Following our conversation this morning we will reproduce this letter as it appears when printed out on the
actual letterhead, and how it appears on screen as a pdf file on my AppleMac. I will then e-mail the pdf to a PC
and we will reproduce how the pdf file looks on that screen.

1 of 1 8.26 × 11.69 in

DUNCAN BAIRD PUBLISHERS

Castle House Sixth Floor 75-76 Wells Street London W1P 3RE

Tel 0171 323 2229 Fax 0171 580 5692

Roger Walton

Duncan Baird Publishers

Castle House

75 - 76 Wells Street

London W1T 3QH

22nd January 2004

Dear Roger,

Here is the letter to be used for the example of screen viewed stationery in 'Designer's Rules for Letterheads'. Following our conversation this morning we will reproduce this letter as it appears when printed out on the actual letterhead, and how it appears on screen as a pdf file on my AppleMac. I will then e-mail the pdf to a PC and we will reproduce how the pdf file looks on that screen.

Yours sincerely,

Rachel

SCREEN TO PAPER

This page:
The same PDF as on the previous pages, but sent via e-mail from the Mac on which it was produced to a PC, and printed out using a bubblejet printer connected directly to that PC. (The result is reproduced here at 62% of the printout size.)

SCREEN TO SCREEN

Opposite top:
Screen grab of the PDF returned from the PC back to the Apple Mac computer, and viewed at 62% of original letterhead size.

Opposite bottom:
As above, but viewed at 100% of original letterhead size.

DUNCAN BAIRD PUBLISHERS

Castle House Sixth Floor 75-76 Wells Street London W1P 3RE

Tel 0171 323 2229 Fax 0171 580 5692

Roger Walton

Duncan Baird Publishers

Castle House

75 - 76 Wells Street

London W1T 3QH

22nd January 2004

Dear Roger,

Here is the letter to be used for the example of screen viewed stationery in 'Designer's Rules for Letterheads'.
Following our conversation this morning we will reproduce this letter as it appears when printed out on the
actual letterhead, and how it appears on screen as a pdf file on my AppleMac. I will then e-mail the pdf to a PC
and we will reproduce how the pdf file looks on that screen.

DUNCAN BAIRD PUBLISHERS

Castle House Sixth Floor 75-76 Wells Street

Tel 0171 323 2229 Fax 0171 580 5692

Roger Walton

Duncan Baird Publishers

Castle House

75 - 76 Wells Street

London W1T 3QH

REFERENCE

further reading

Here is a completely subjective, short list
of essential books for the designer:

A Year (with Swollen Appendices)
Brian Eno
Faber and Faber, 1996

**Everything Reverberates: Thoughts on
Design**
Chronicle Books, 1998

Hot Designers Make Cool Fonts
Allan Haley
Rockport Publishers, 1988

Paul Rand
Steven Heller
Phaidon Press, 2000

Paul Rand: American Modernist
Jessica Helfand
William Drenttel New York, 1998

REFERENCE

Soak Wash Rinse Spin
Tolleson Design
Princeton Architectural Press, 2000

Stop Stealing Sheep (and Find Out How Type Works)
Erik Spiekermann and E. M. Ginger
Adobe Press,
published by Prentice Hall Computer
Publishing, 2000

The Cheese Monkeys
Chip Kidd
Scribner, 2001

The Elements of Typographic Style
Robert Bringhurst
Hartley & Marks Publishers, 2001

The Form of the Book: Essays on the Morality of Good Design
Jan Tschichold
Hartley & Marks Publishers, 1996

The Virgin Suicides
Jeffrey Eugenides
Farrar, Straus and Giroux, 1993

Tibor Kalman: Perverse Optimist
Michael Bierut (editor)
Booth-Clibborn Editions, 1998

Unforgettable: Images that have Changed our Lives
Peter Davenport
Chronicle Books, 2003

Ways of Seeing
John Berger
Penguin Books, 1972

designer's details

atelier: doppelpunkt
kommunikationsdesign gmbh
Lehrter Strasse 57,
10557 Berlin, Germany.
t: 00 4930 3906 3930
f: 00 4930 3906 3940
e: atelier@doppelpunkt.com
w: www.doppelpunkt.com

Aufuidish & Warinner
183 The Alameda,
San Anselmo,
CA 94960, USA.
t: 00 141 5721 7921
f: 00 141 5721 7965
e: bob@aufwar.com
w: www.aufwar.com

Baby Creative
William Blake House,
8 Marshall Street,
London W1F 7BD, UK.
t: 00 4420 7734 0282
f: 00 4420 7439 8884
e: robin@babycreative.com
w: www.babycreative.com

Danielle Foushée Design
1373 N 310 W No.2,
Logan, UT 84341, USA.
t: 00 181 8613 7459
e: info@daniellefoushee.com
w: www.daniellefoushee.com

Deanne Cheuk Design
e: neomuworld@aol.com
w: www.neomu.com

D-Fuse
PO Box 39943,
London EC1V OYZ, UK.
t: 004420 7253 3462
e: info@dfuse.com
w: www.dfuse.com

d groupe
2318 University Boulevard,
Tuscaloosa, Alabama 35401, USA.
w: www.dgroupe.com

Goldfinger C.S.
684 Antone Street, Studio 109,
Atlanta, GA 30318, USA.
t: 00 140 4352 1952
f: 00 140 4355 5519
e: dl@goldfingercreative.com
w: www.goldfingercreative.com

HDR Visual Communication
Bradbourne House,
Bradbourne Lane,
East Malling, Kent,
ME19 6DZ, UK.
t: 00 4417 3287 5200
f: 00 4417 3287 5300
e: mail@hdr-online.com
w: www.hdr-online.com

IAAH / iamalwayshungry
2509 Annunciation Street,
New Orleans, LA 70130, USA.
e: ness@iamalwayshungry.com
w: www.iamalwayshungry.com

Julian Morey Studio
Studio 116, 31 Clerkenwell Close,
London EC1R 0AT, UK.
t: 00 4420 7336 8970
f: 00 4420 7336 8970
e: info@eklektic.co.uk
w: www.eklektic.co.uk

Kursiv
Wildersgade 37,
DK 1408, Denmark.
t: 00 45 3296 9446
e: kursiv@kursiv.dk
w: www.kursiv.dk

Lies Ros
Plantage Kerklaan 2/3,
1018 TA Amsterdam,
The Netherlands.
t: 00 312 0625 1891
f: 00 312 0625 1891
e: liesr@xs4all.nl

Lightship Visual
7 Gordon Street,
Bayswater 6053,
Western Australia, Australia.

t: 00 618 9271 8289
f: 00 618 9371 7300
e: lightship@arach.net.au
w: www.arach.net.au/~lightship

Martijn Oostra Graphic Design
Donker Curtiusstraat 25e,
NL-1051 HT, Amsterdam,
The Netherlands.
t: 00 312 0688 9646
f: 00 318 4233 6131
e: info@oostra.org

Mint
192 Clapham High Street,
London SW4 7UD, UK.
t: 00 4420 7627 0066
f: 00 4420 7627 0676
e: mail@mint-design.co.uk
w: www.mint-design.co.uk

R. Walton Studio
c/o Duncan Baird Publishers,
Castle House, Sixth Floor,
75–6 Wells Street,
London W1T 3QH, UK.
t: 00 4420 7454 8523

Ryan & Deslauriers
290 Place Youville Stables,
Montreal, Quebec H2Y 2B6,
Canada.
t: 00 151 4287 1555

REFERENCE

f: 00 151 4287 1918
e: ryan@ryanonline.com
w: www.ryanonline.com

Segura Inc.
1110 North Milwaukee Avenue,
Chicago, Illinois 60622.4017, USA.
t: 00 177 3862 5667
f: 00 177 3862 1214
e: carlos@segura-inc.com
w: www.segura-inc.com

Stoltze Design
49 Melcher Street, 4th Floor,
Boston, Massachusetts 02210, USA.
t: 00 161 7350 7109
f: 00 161 7482 1171
e: cliff@stoltze.com
w: www.stoltze.com

Substance®
Back of 153 Gibralter Street,
Sheffield S3 8UA, UK.
t: 00 4411 4281 3053
e: oscargoldman@imagesofsubstance.com
w: www.imagesofsubstance.com

344 Design, LLC
Pasadena, California, USA.
t: 00162 6796 5148
f: 00156 1658 8418
e: contact@344design.com
w: www.344design.com

Voice Design
217 Gilbert Street,
Adelaide, Australia.
t: 00 618 8410 8822
f: 00 618 8410 8933
e: info@voicedesign.net
w: www.voicedesign.net

Wood / Brod Design
3662 Grandin Road,
Cincinnati, Ohio 45226, USA.
t: 00 151 3924 1126
f: 00 151 3924 1125
e: stan_brod@excite.com

Yam
56b Market Place,
London NW11 6JP, UK.
t: 00 4420 8455 1805
e: craigyamey@hotmail.com

Zip Design Ltd.
Unit 2A, Queen's Studio,
121 Salusbury Road,
London SW16 1HD, UK.
t: 004420 7372 4474
f: 004420 7372 4484
e: info@zipdesign.co.uk
w: www.zipdesign.co.uk

234

index

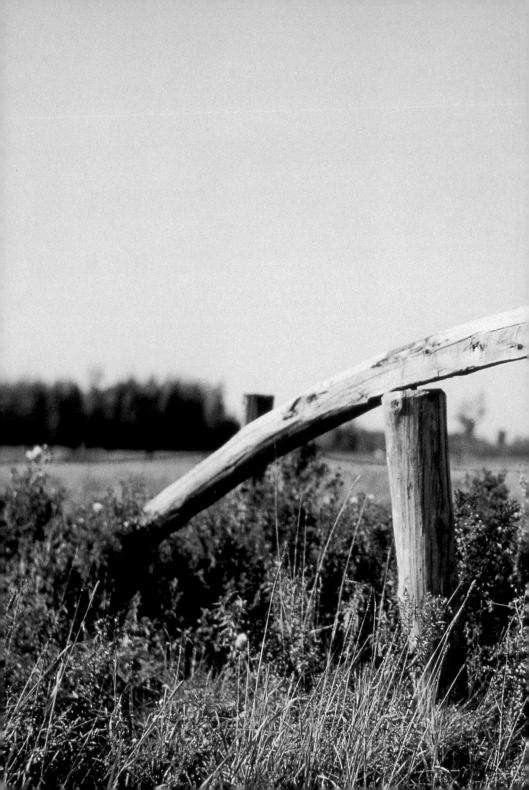

acknowledgments / afterword

Picture credits

The publisher would like to thank the following people, museums, and photographic libraries for permission to reproduce their material. Every care has been taken to trace copyright holders. However, if we have omitted anyone we apologize and will, if informed, make corrections to any future edition.

page 8–9 Private collection / The Art Archive, London; page 238–39 © Museum of Fine Arts, Houston, Texas / Gift of Howard Greenberg / The Bridgeman Art Library, London; all other photography by White Backgrounds.

With thanks

My thanks to the following people for their help on this book:
Rachel Cross for the excellent design and typography
Simon Ryder for all the editorial work and advice
Lizzy Dann for managing the submission process, and the queries we had for
the letterhead designers
Everyone who submitted work
Angela Young and Richard Hayes of Imago Publishing for their technical advice
Caroline and Roger Hillier for technical advice and lunch
Stanley (age 12) for assisting with the Mac to PC file-swapping experiment (see pp. 220–25)
Oscar (age 9) for the story about the tree that was arrested for falling on a boy (not actually included in this book, but a belting tale nonetheless!)
Carolyn for everything

Afterword

This book is set in Trade Gothic 18, the condensed face of Trade Gothic, which was originally designed by Jackson Burke for Linotype between the years 1948 and 1960. Its large x-height and condensed characters have made it both popular as a text face and, in it's bold weight, as an extremely effective and much used headline face, often seen in magazines, newspapers, and advertizing.